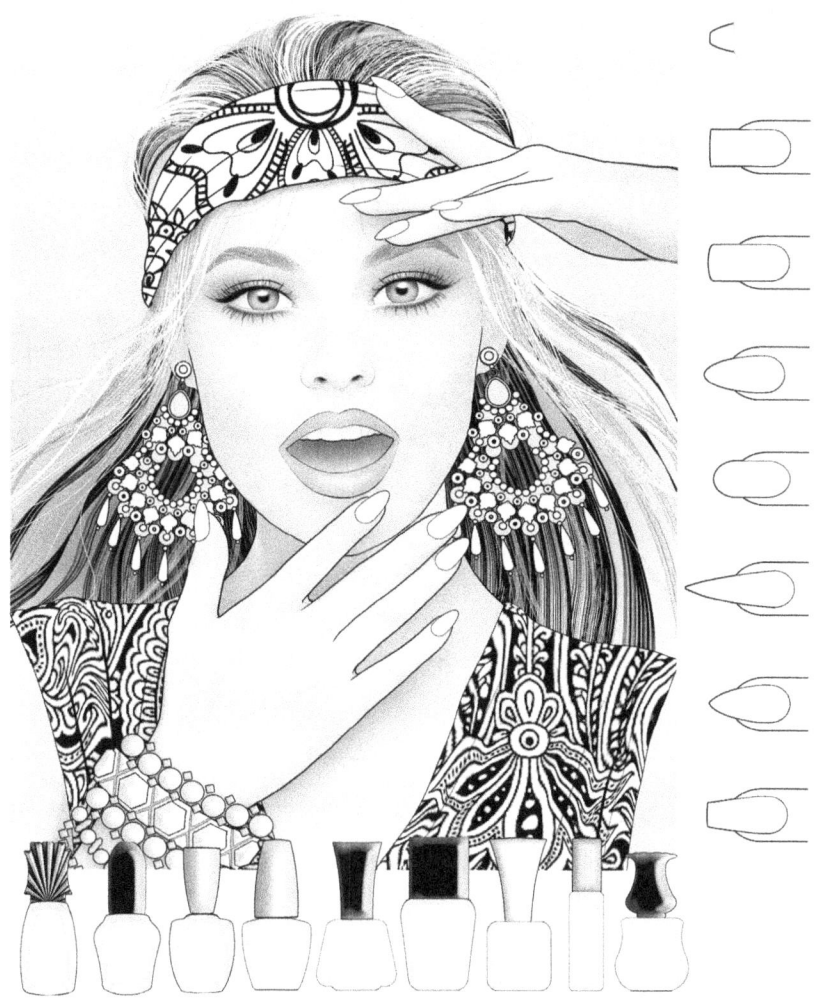

Create Your Own Nail Spa

I hope you enjoy this fun colour-in book
which contains great projects
and fun clients to practice with.
You will learn some aspects of
the glamorous world of Nail Art

Have Fun

Practice your Nail Art Skills

Your special Clients are ready

At the back of the book are some handy templates
where you can catalogue your own nail polish collection
or create more nail art or just enjoy colouring in.

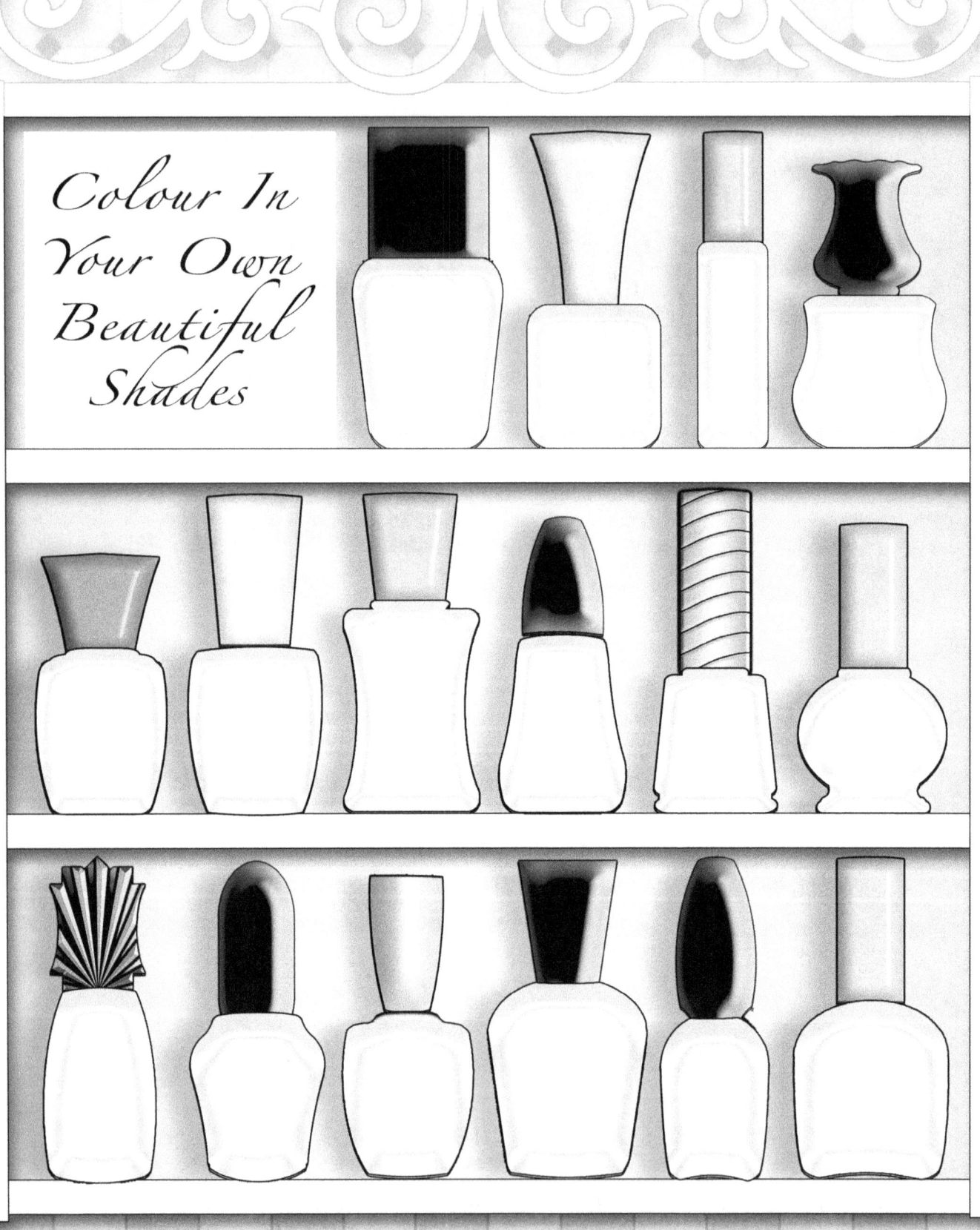

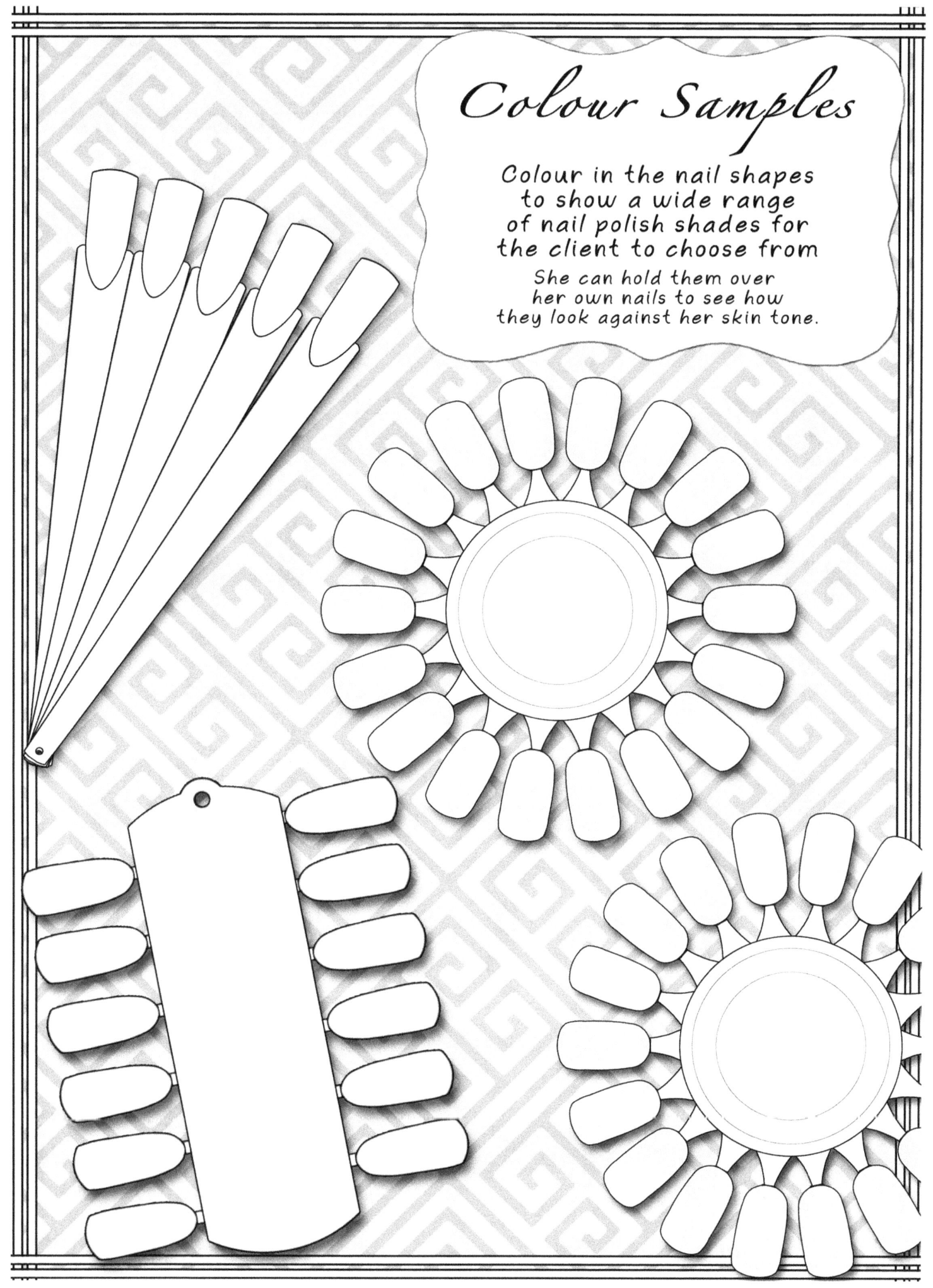

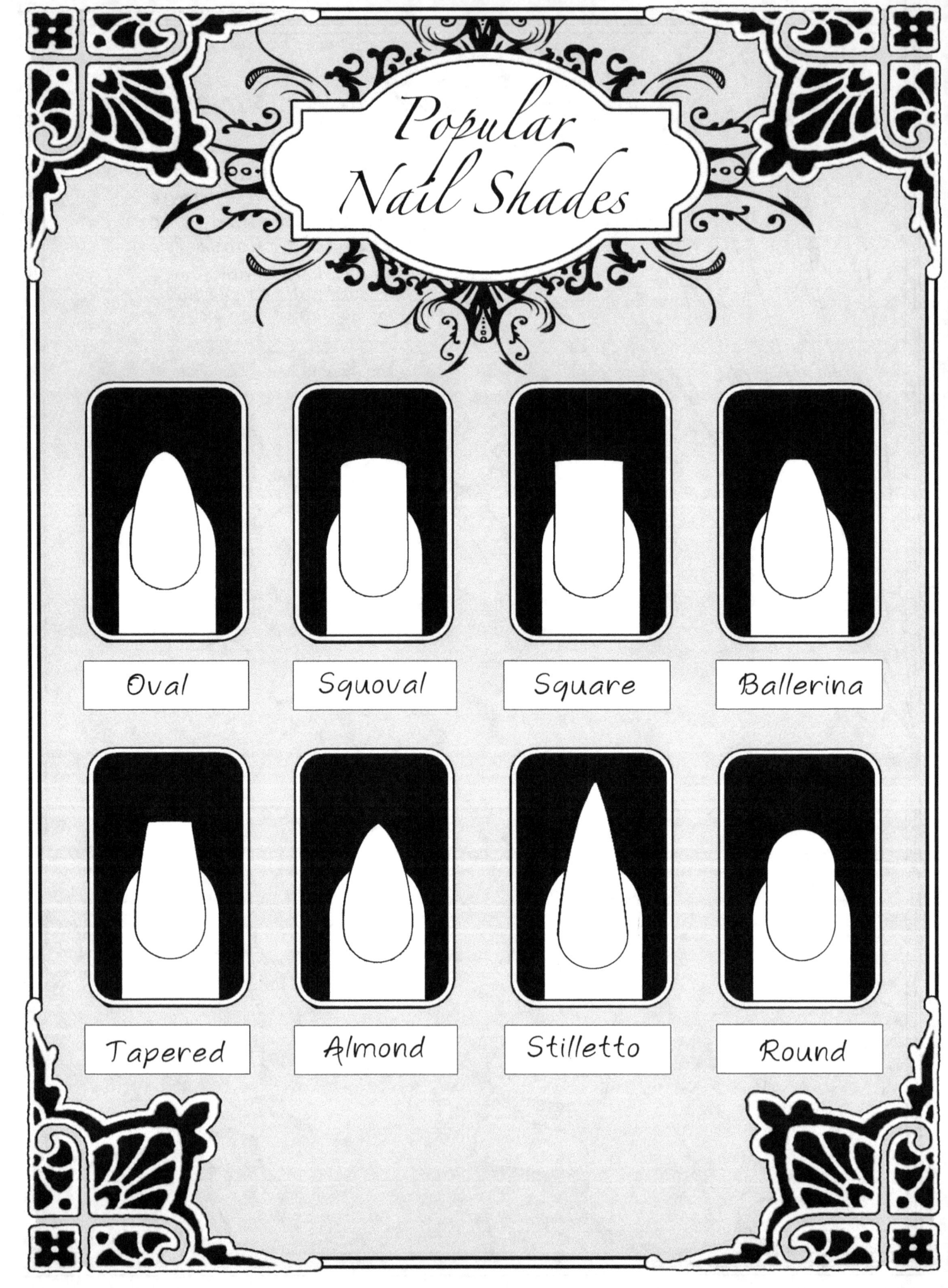

Types Of Polish

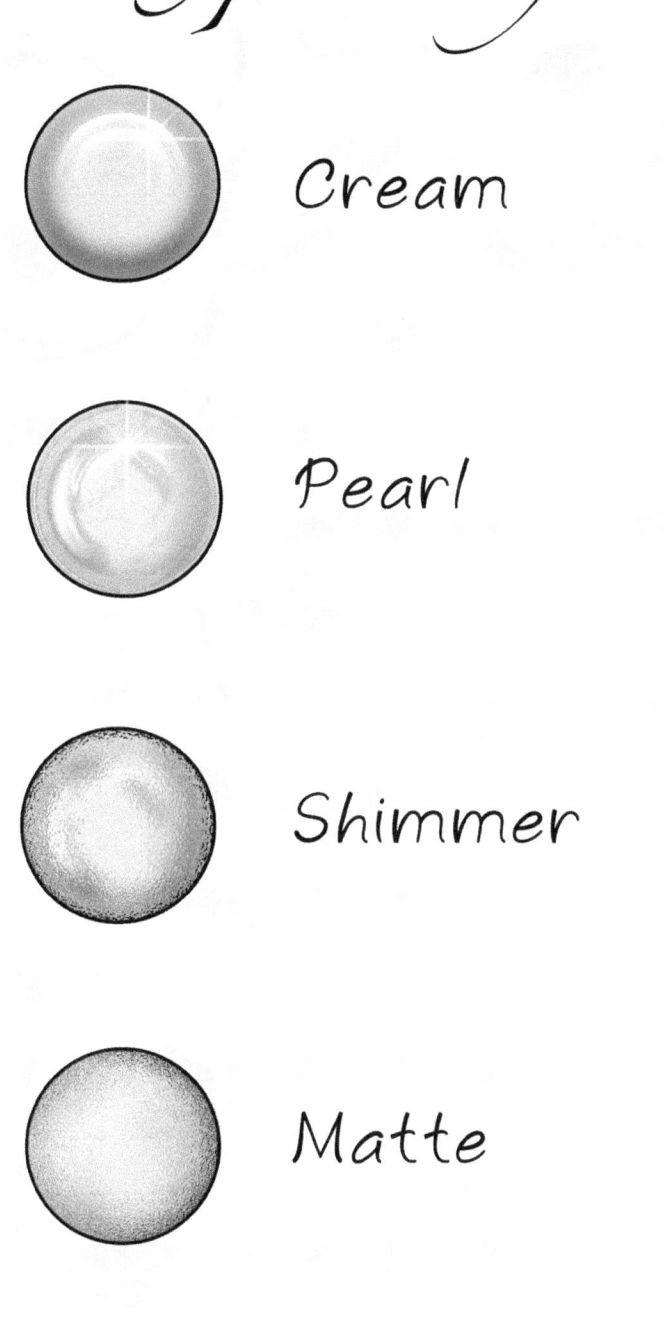
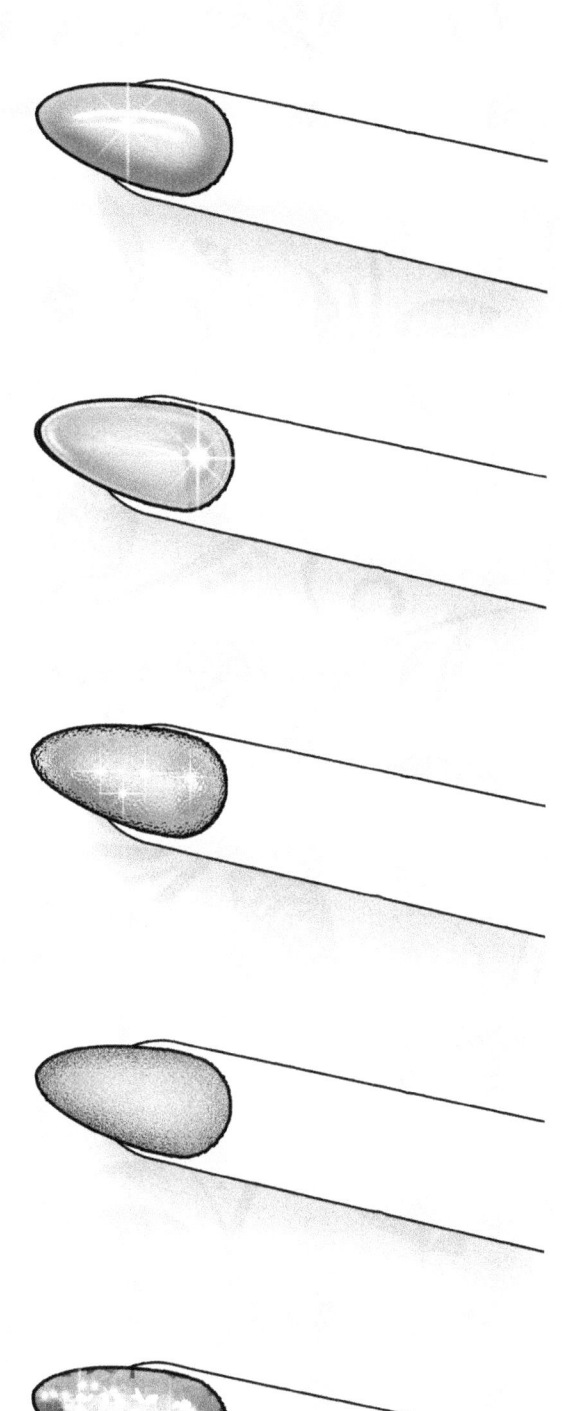

- Cream
- Pearl
- Shimmer
- Matte
- Glitter

Special Effects Nail Polish

- Crackle
- Glitter
- Holographic
- Hexagonal Glitter
- Magnetic

Special Effects Nail Polish

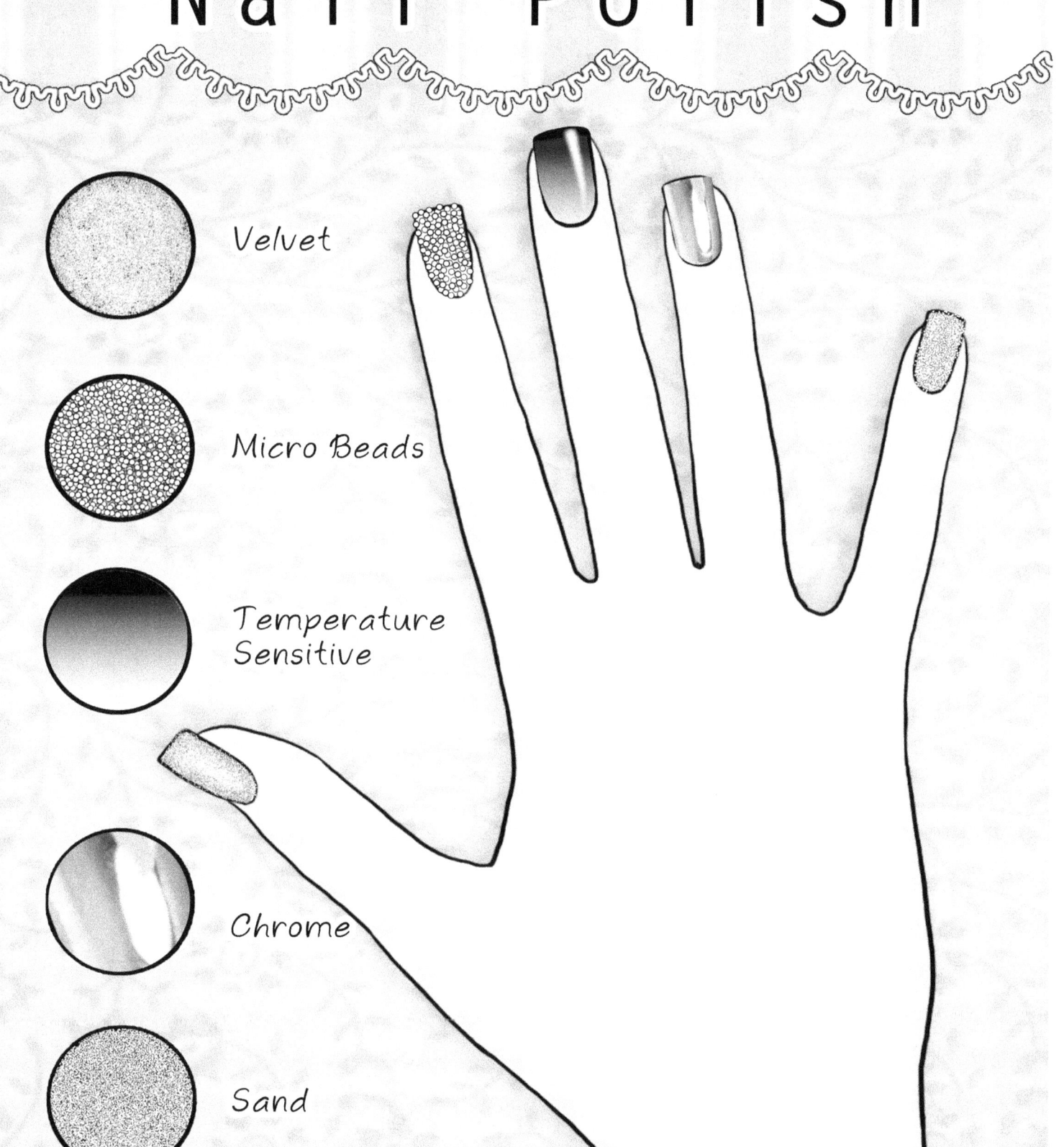

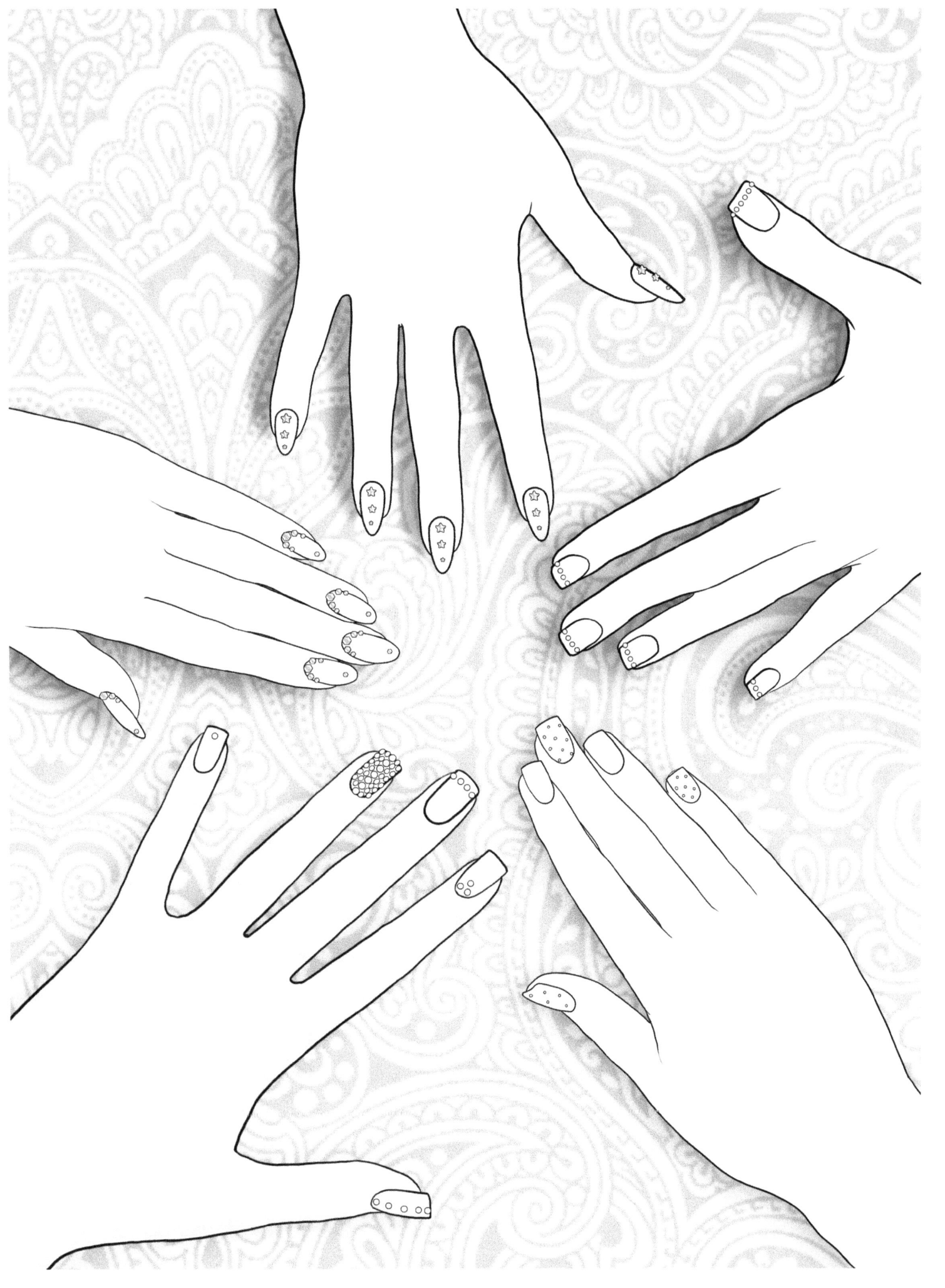

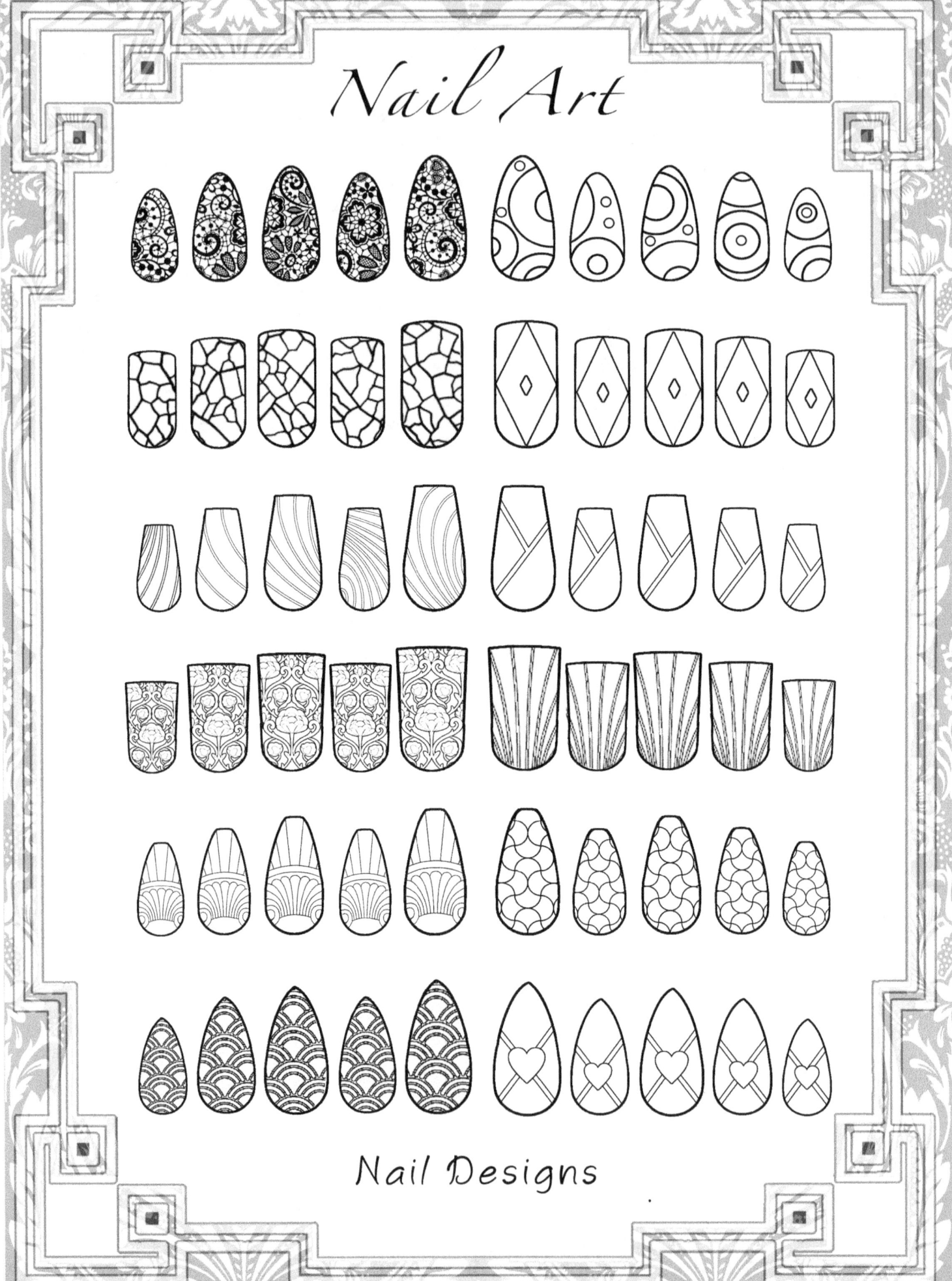

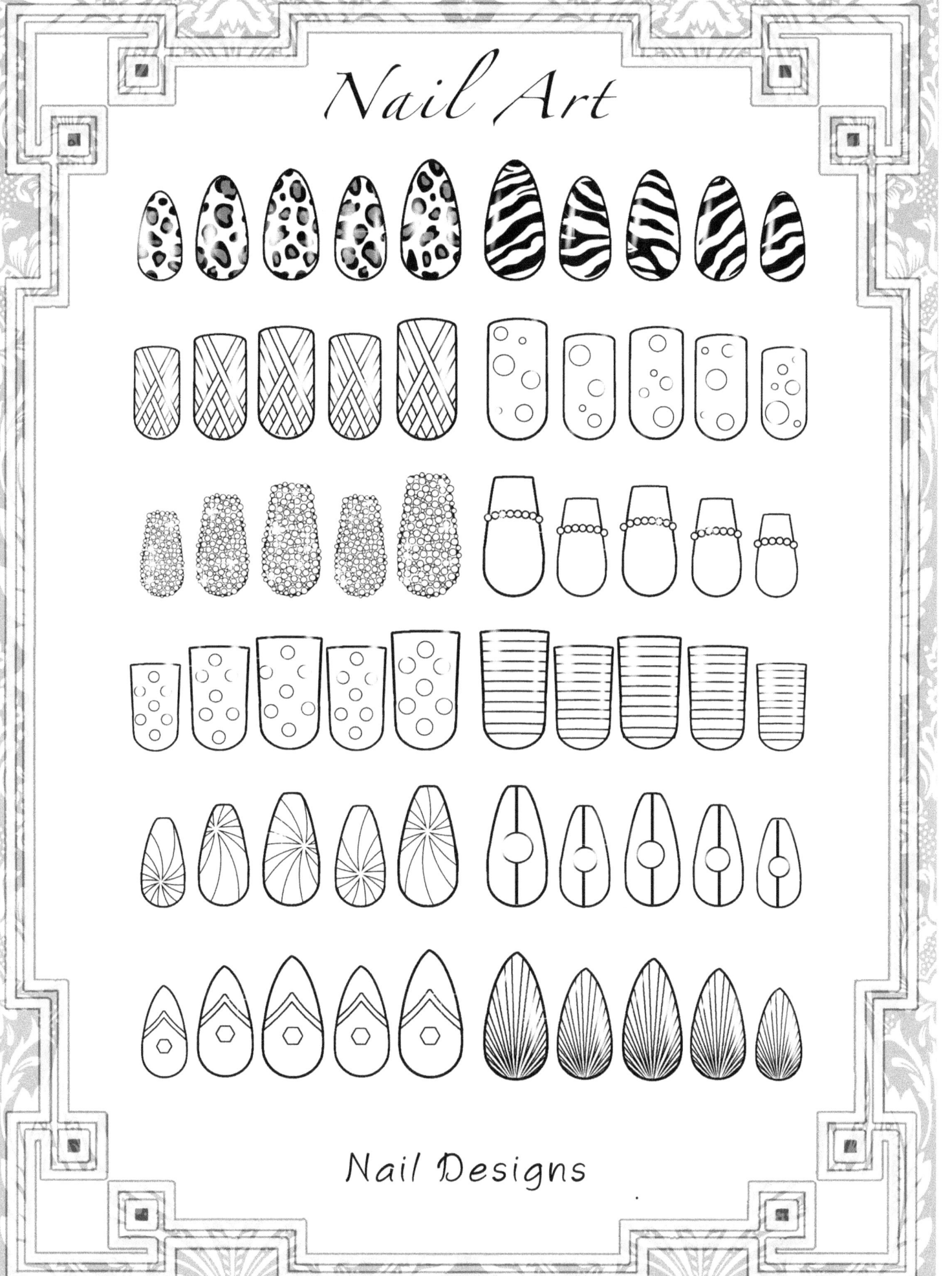

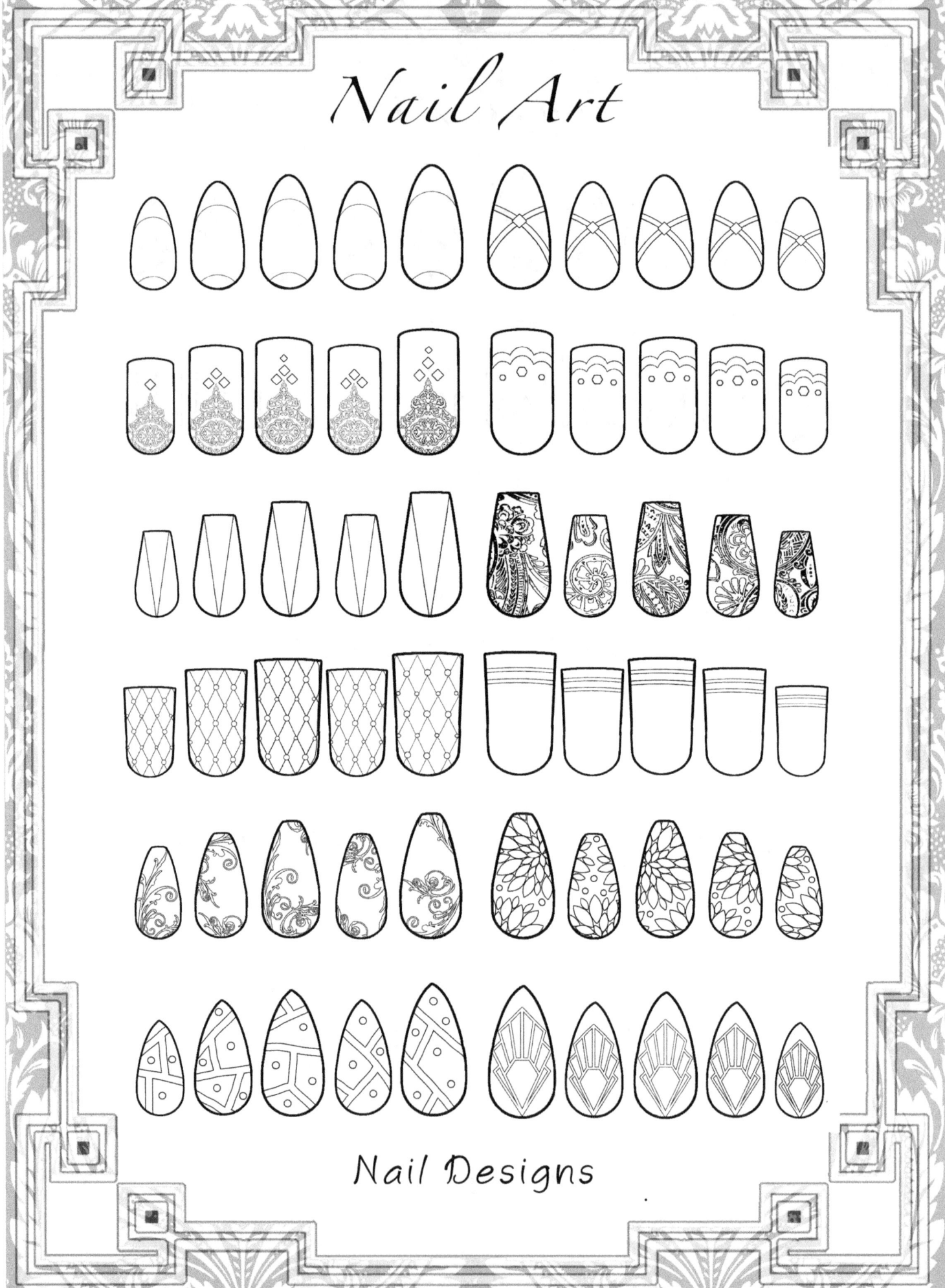

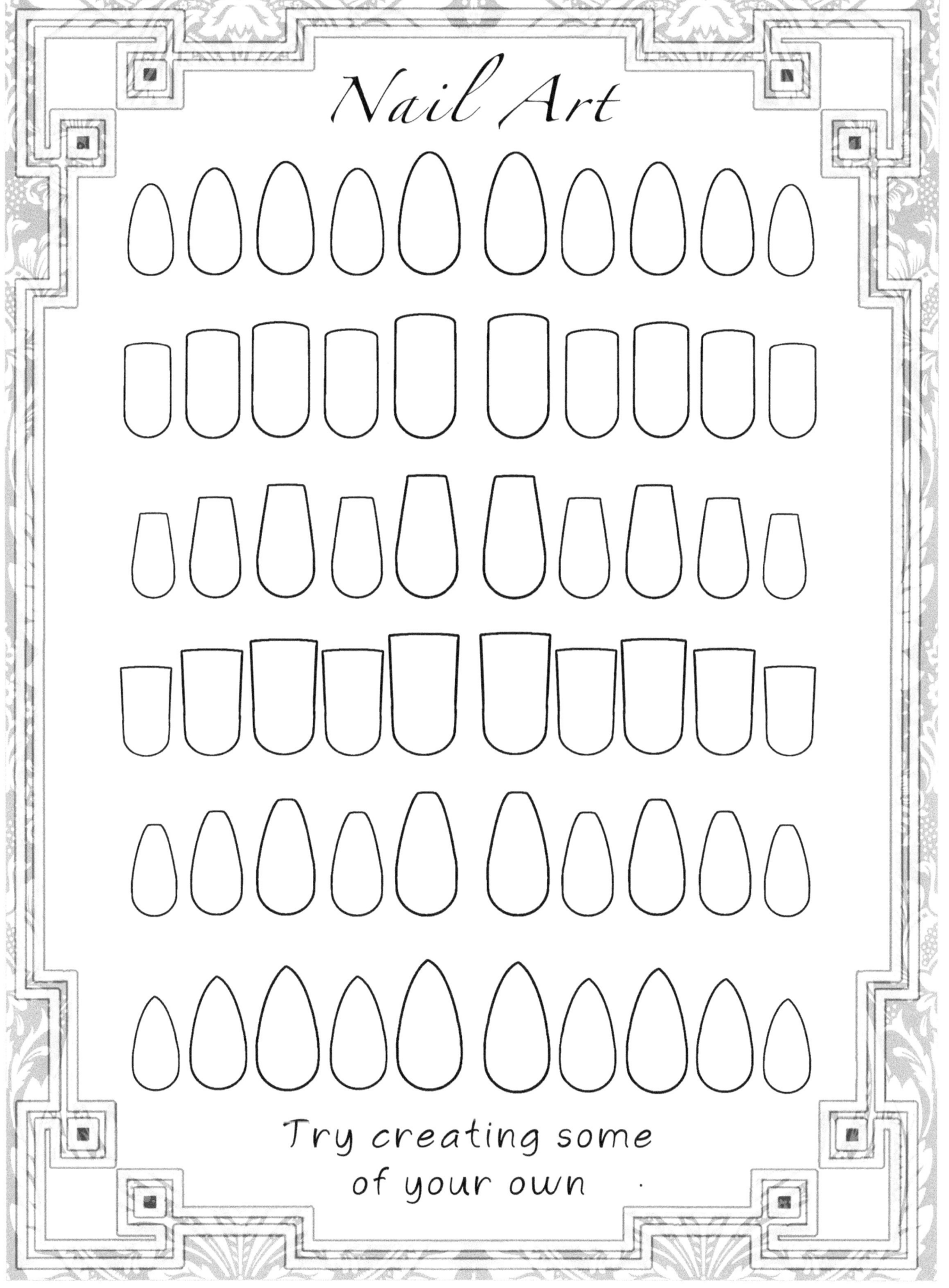

Brush Up On Your
Free Hand

Copy the designs on the left or create your own!

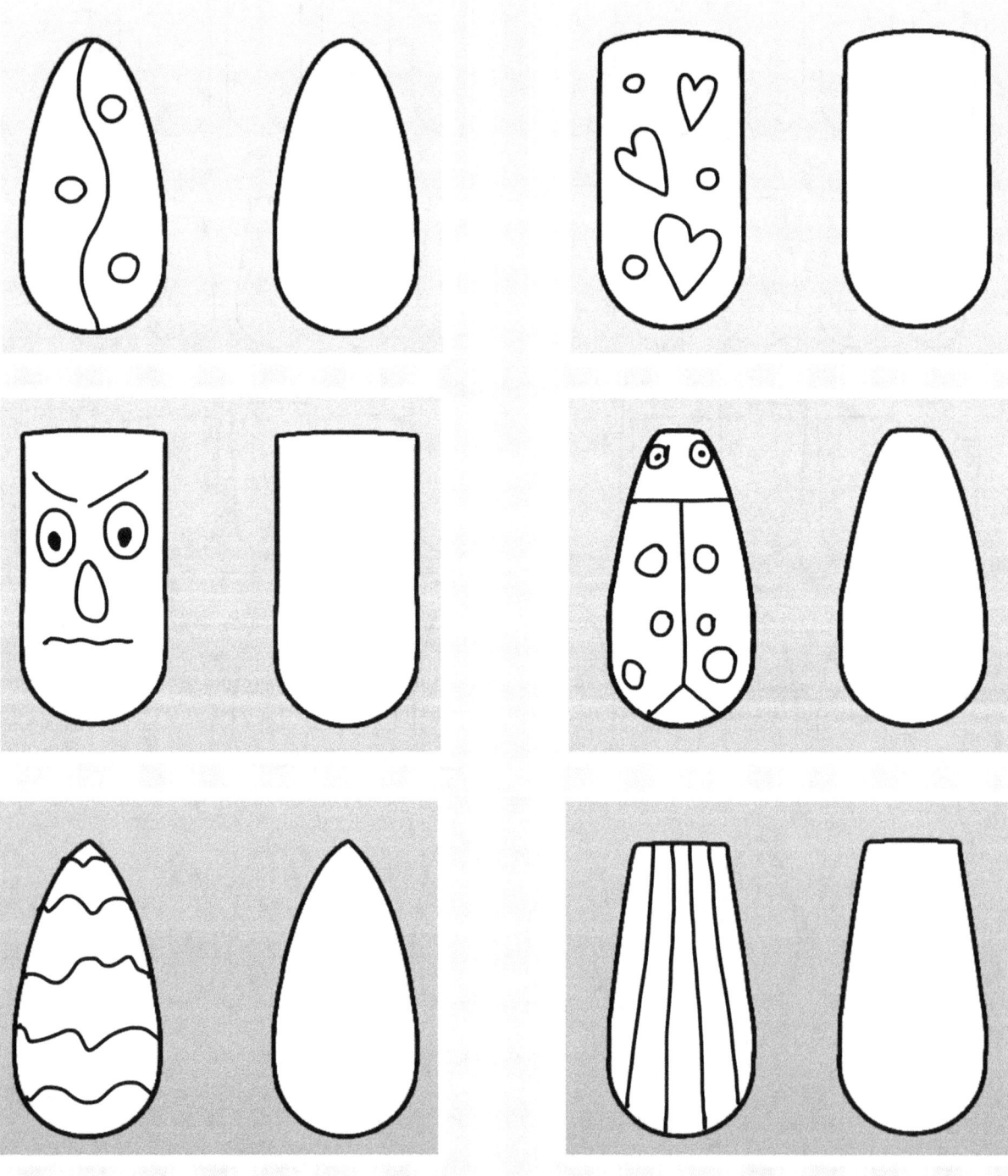

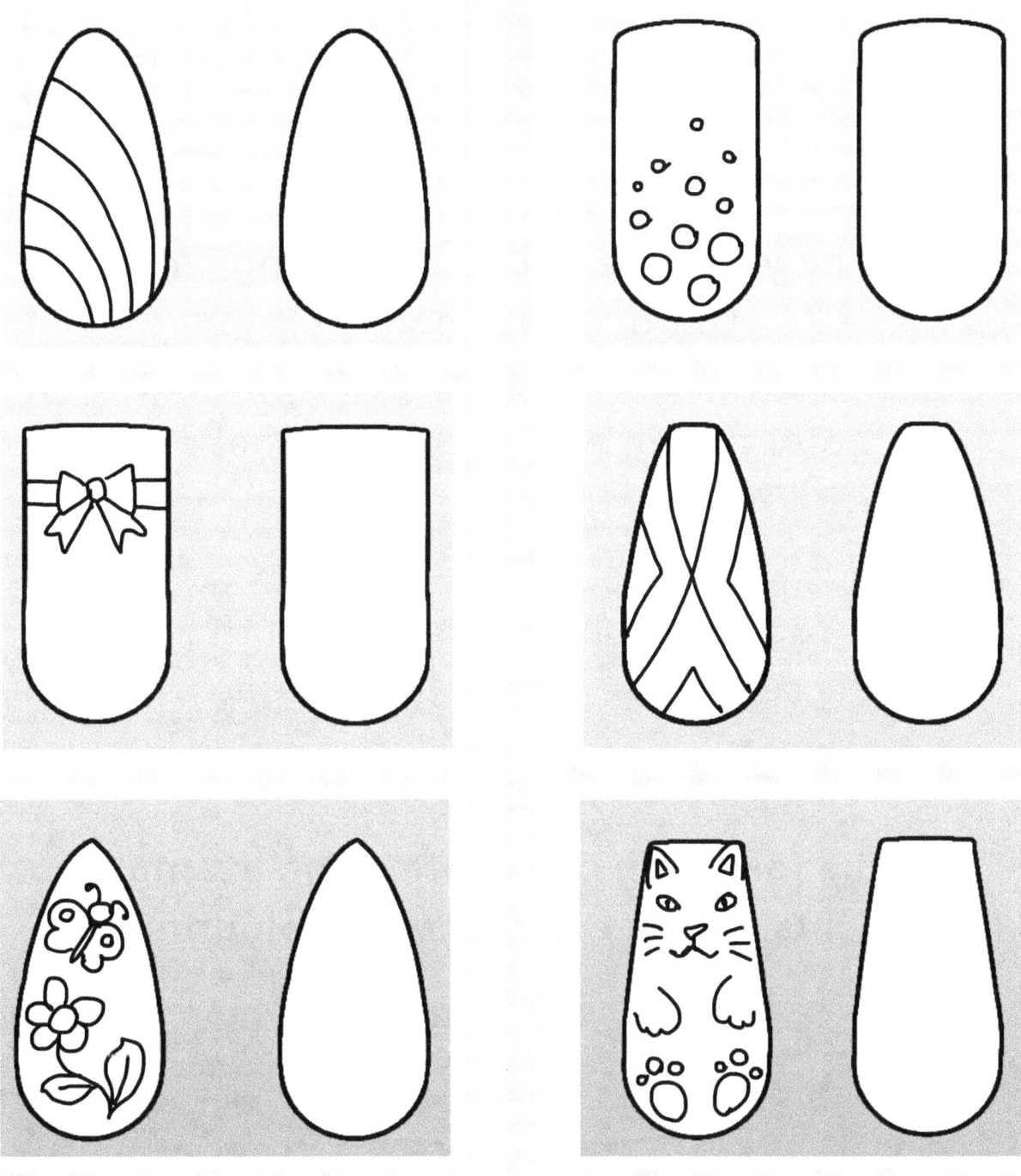

Well Done

I hope you have enjoyed learning some things about nail art.
By now you should be really good at colouring in and decorating nails.

You can fill in the details on the certificate on the next page.

On the following pages are some examples of clients who need their nails colouring in.

Awarded To

_____ _____
First Name Surname

Who has successfully coloured in all the nail designs on the previous pages.

Signature of witness

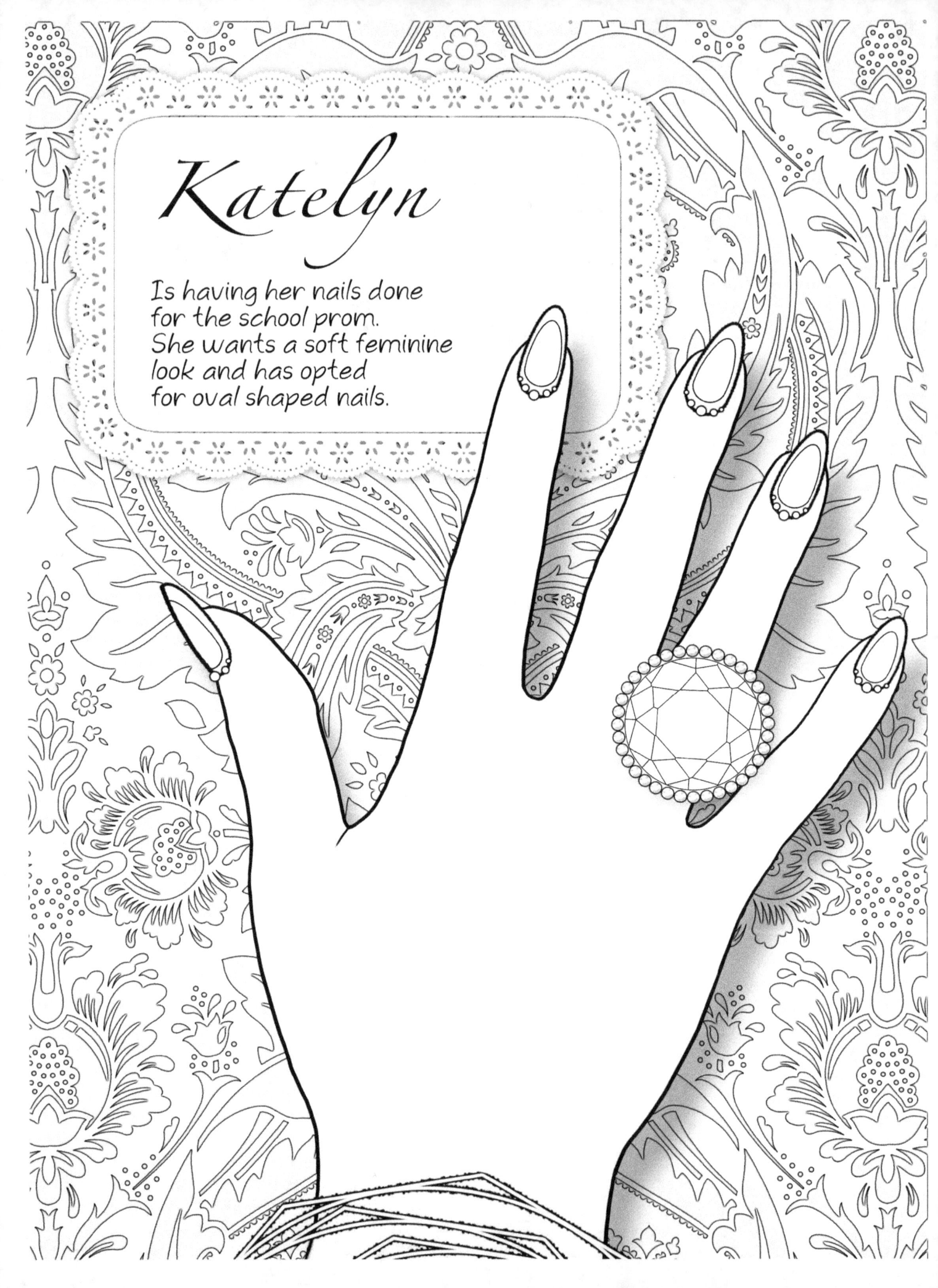

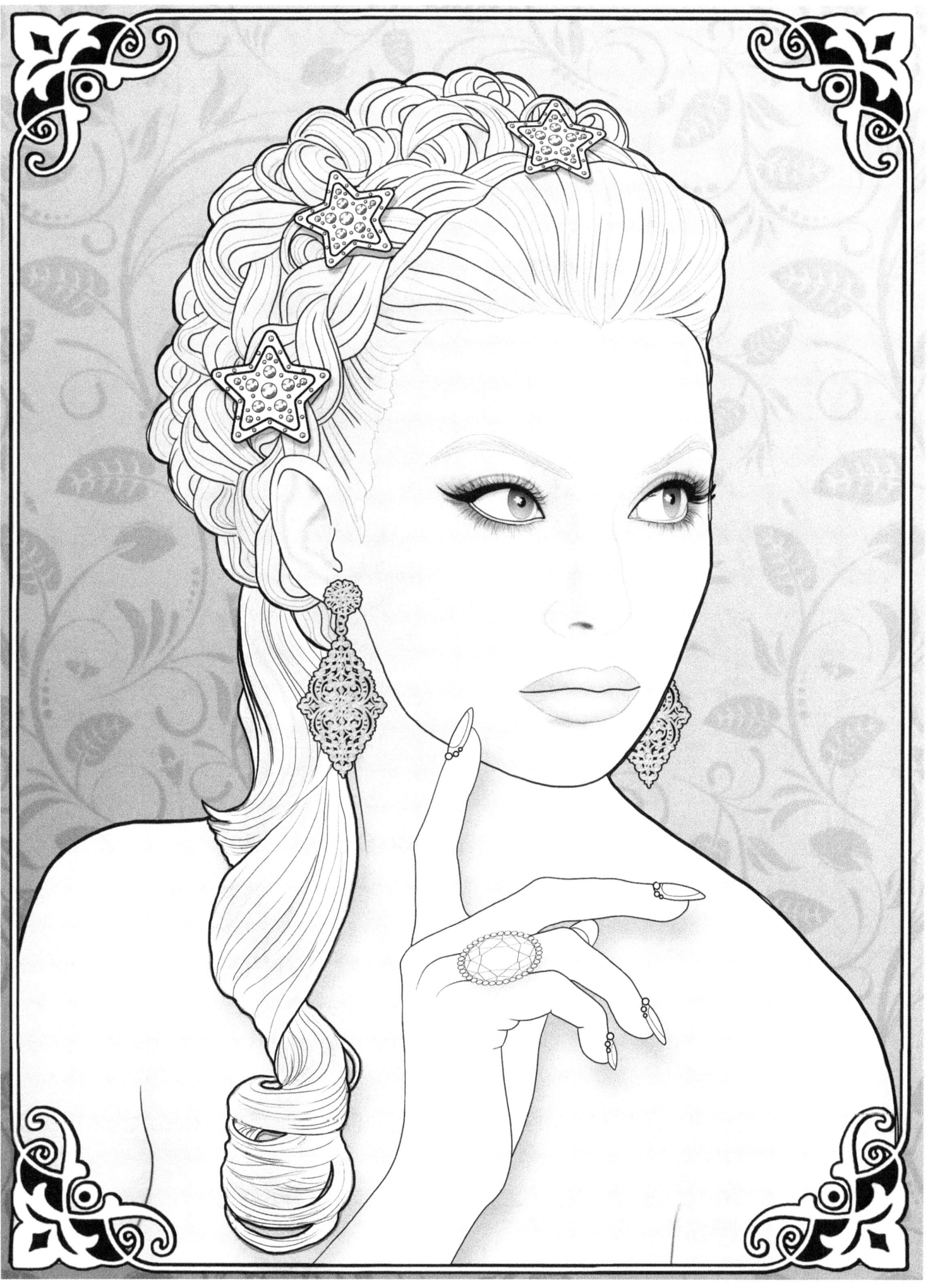

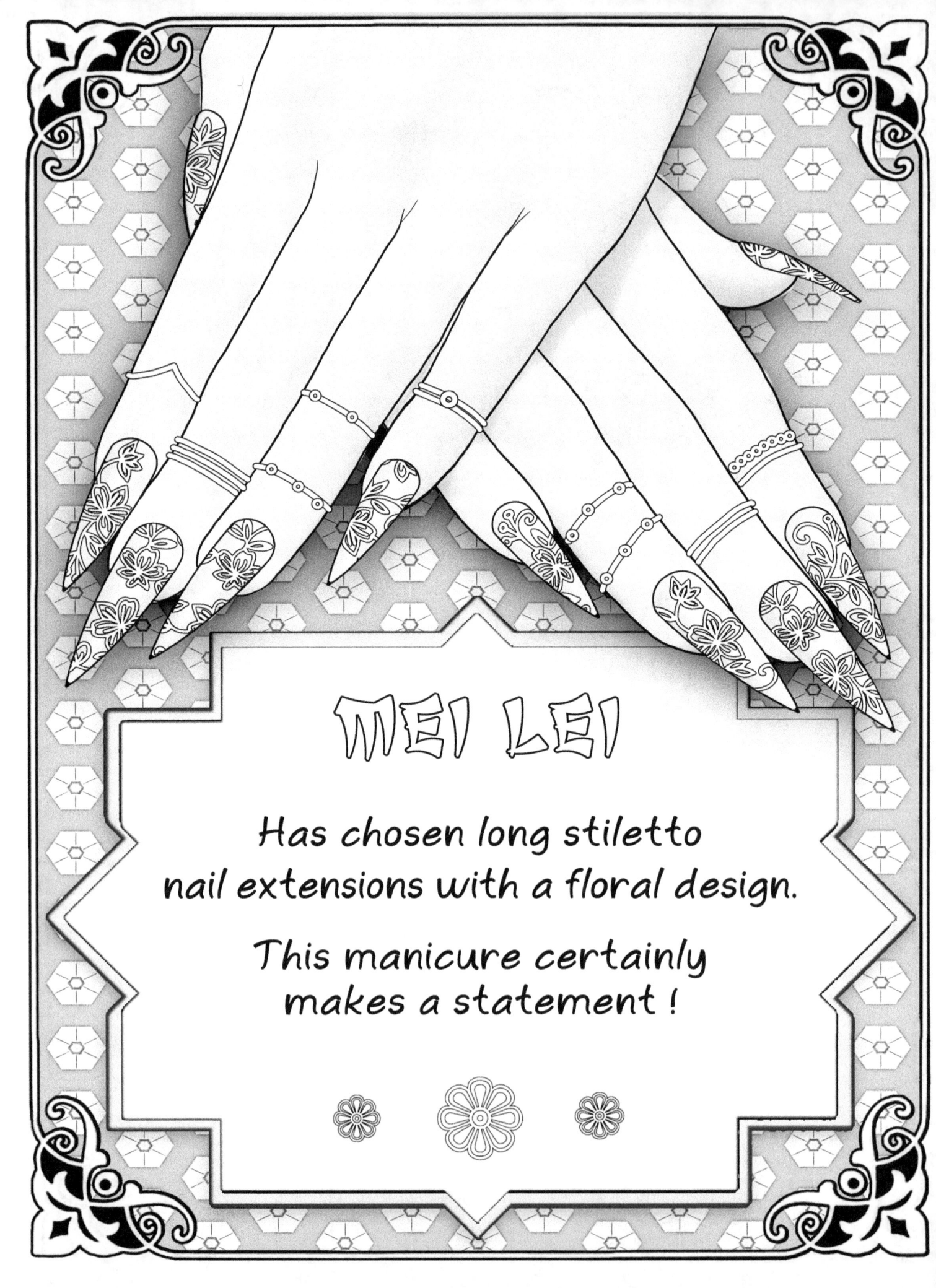

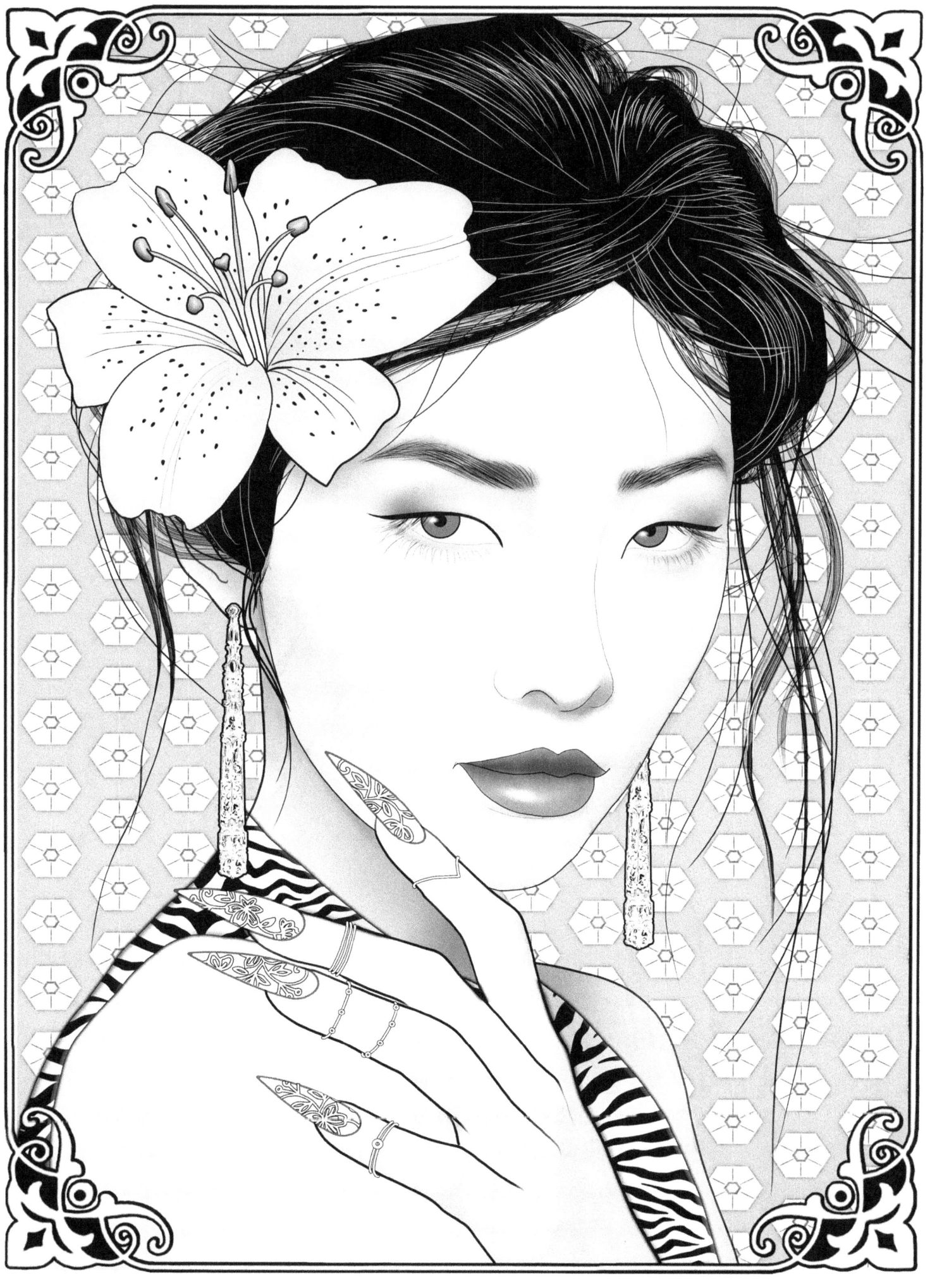

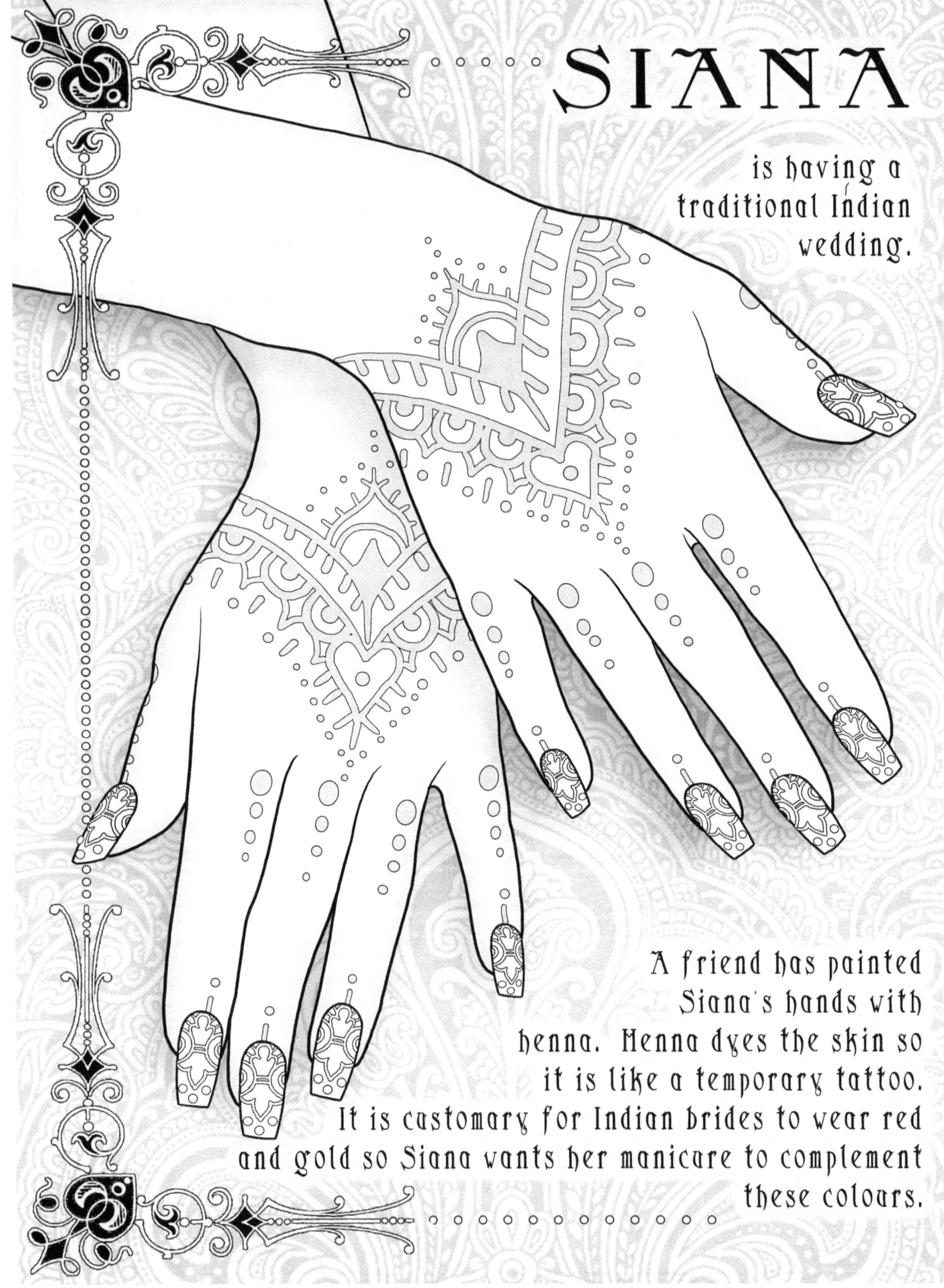

SIANA

is having a traditional Indian wedding.

A friend has painted Siana's hands with henna. Henna dyes the skin so it is like a temporary tattoo. It is customary for Indian brides to wear red and gold so Siana wants her manicure to complement these colours.

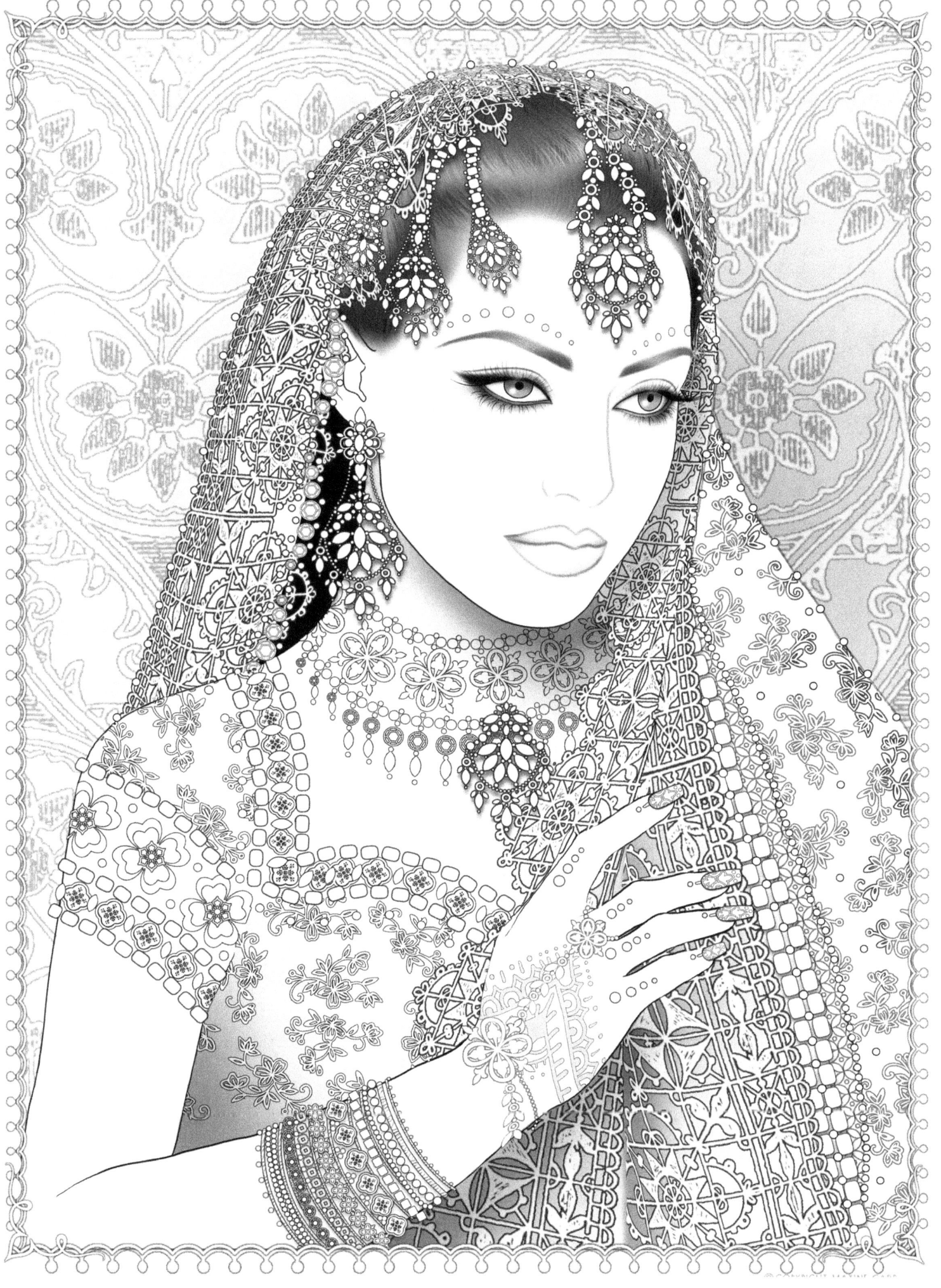

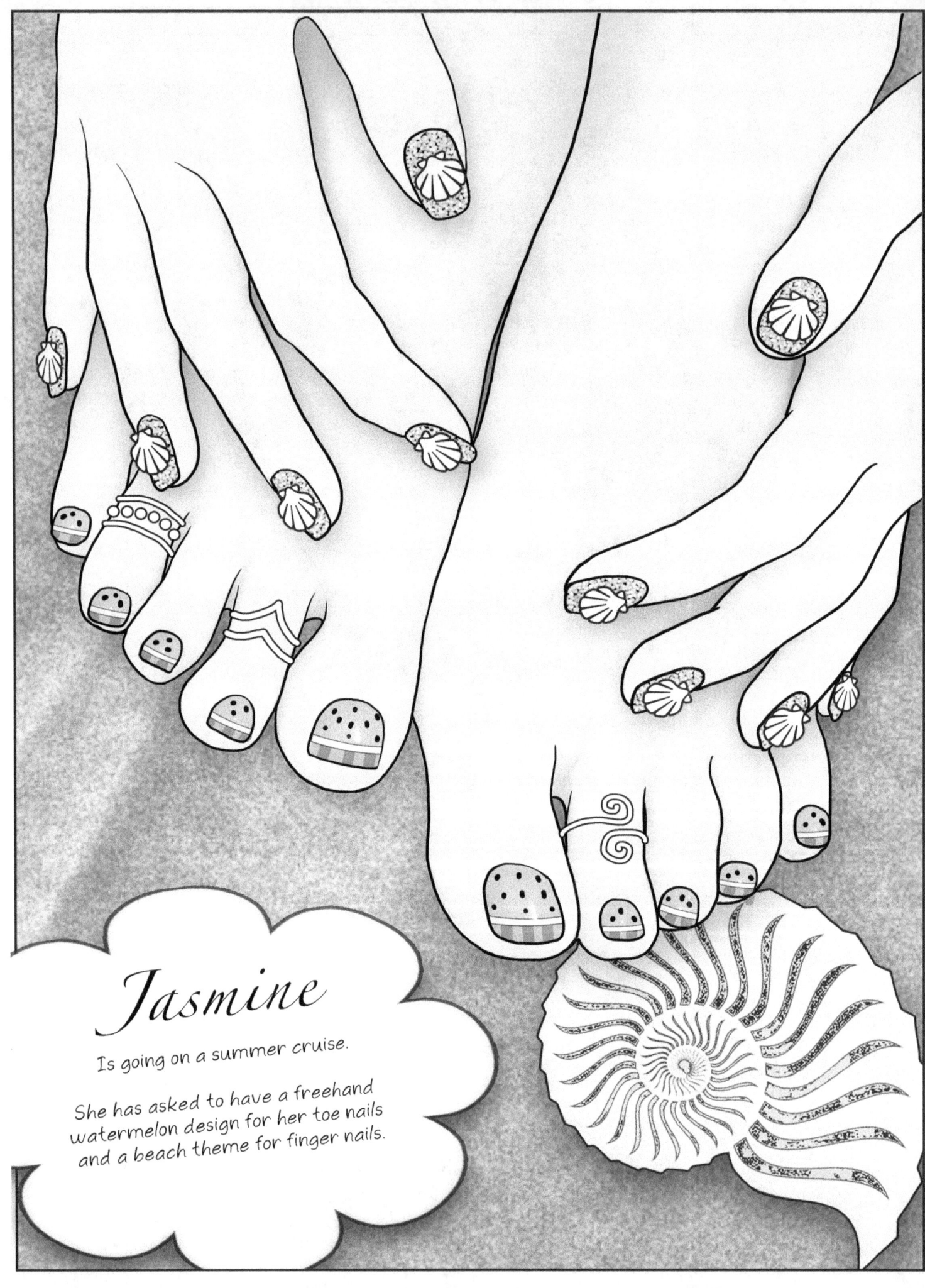

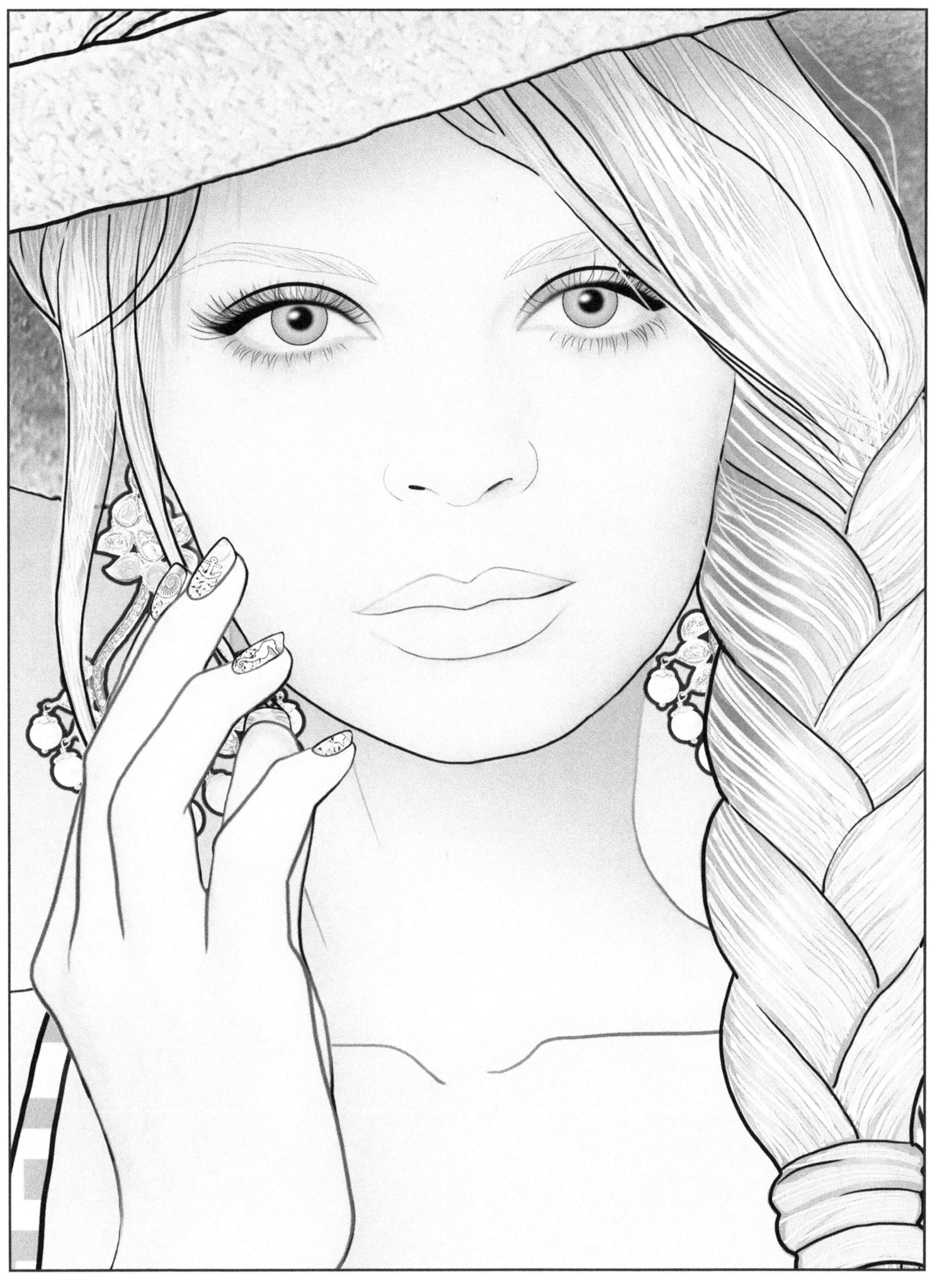

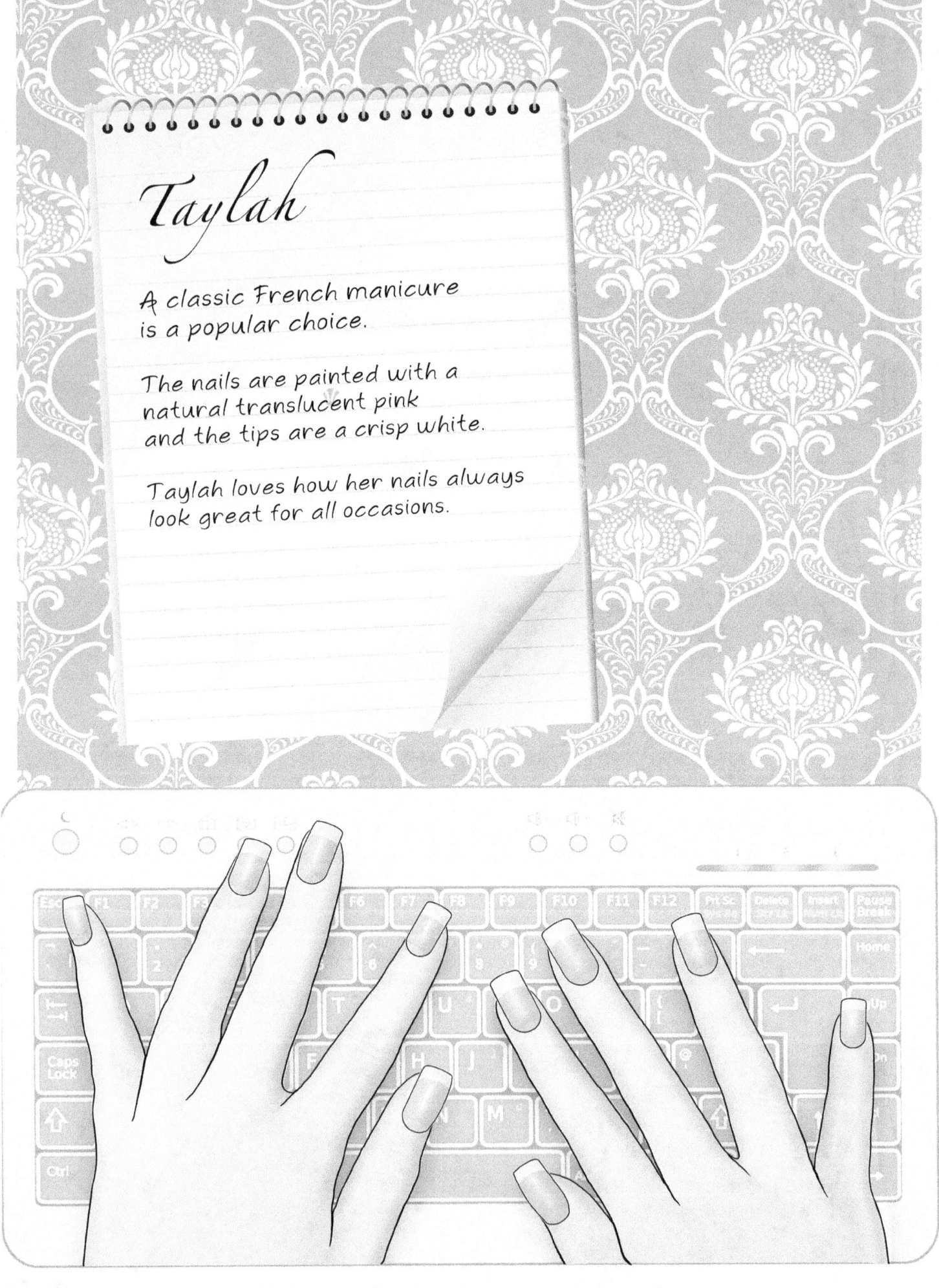

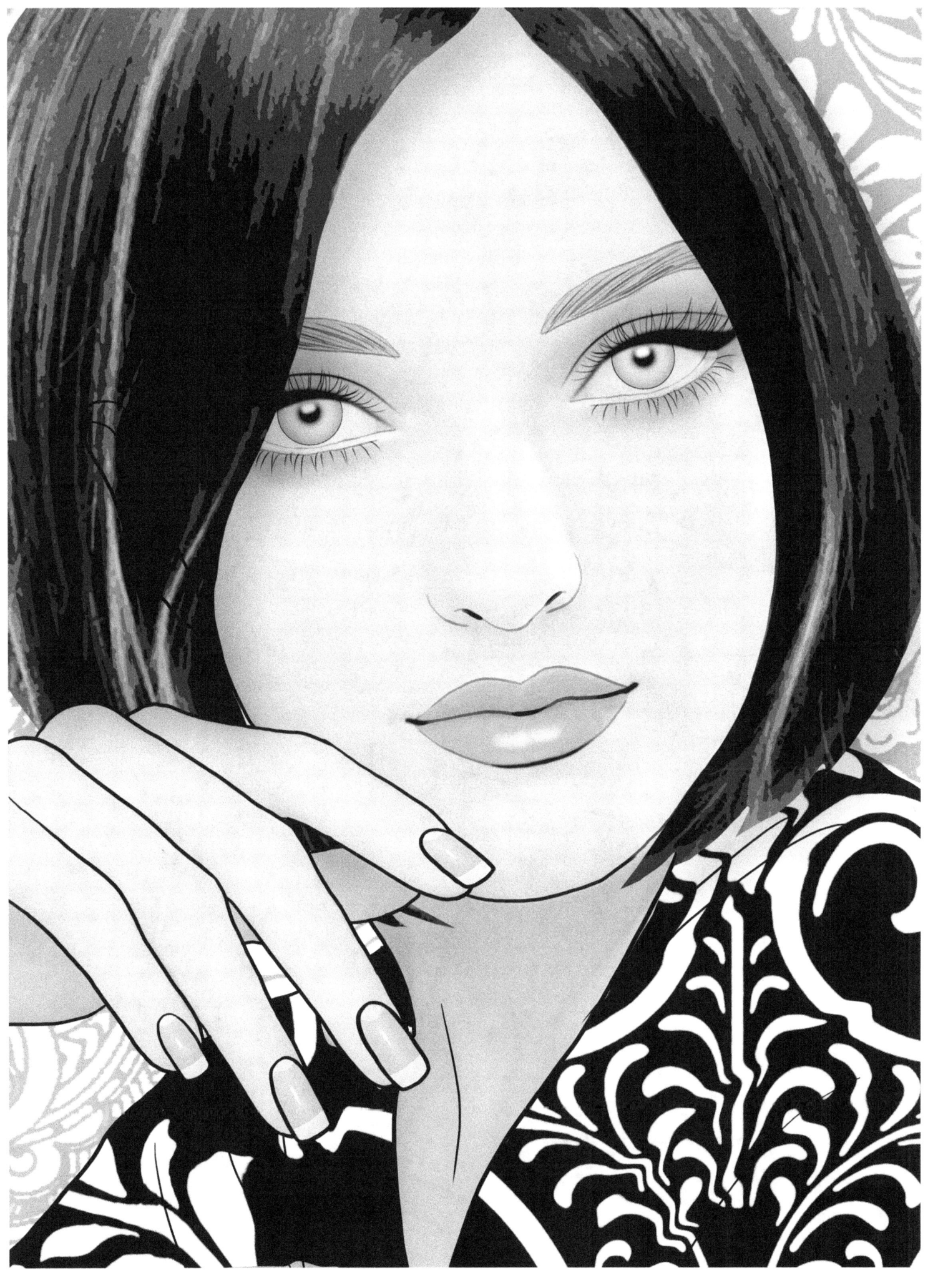

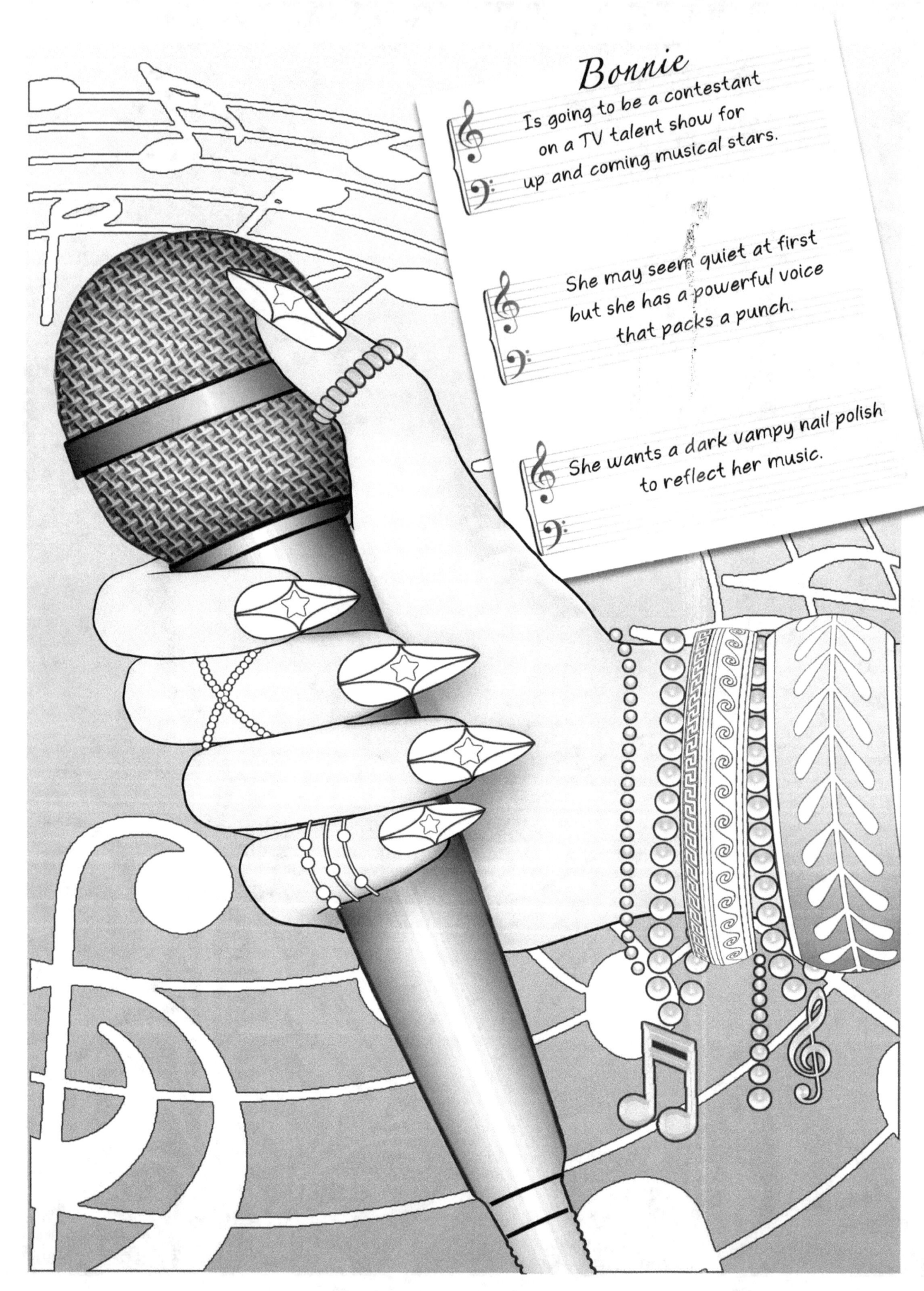

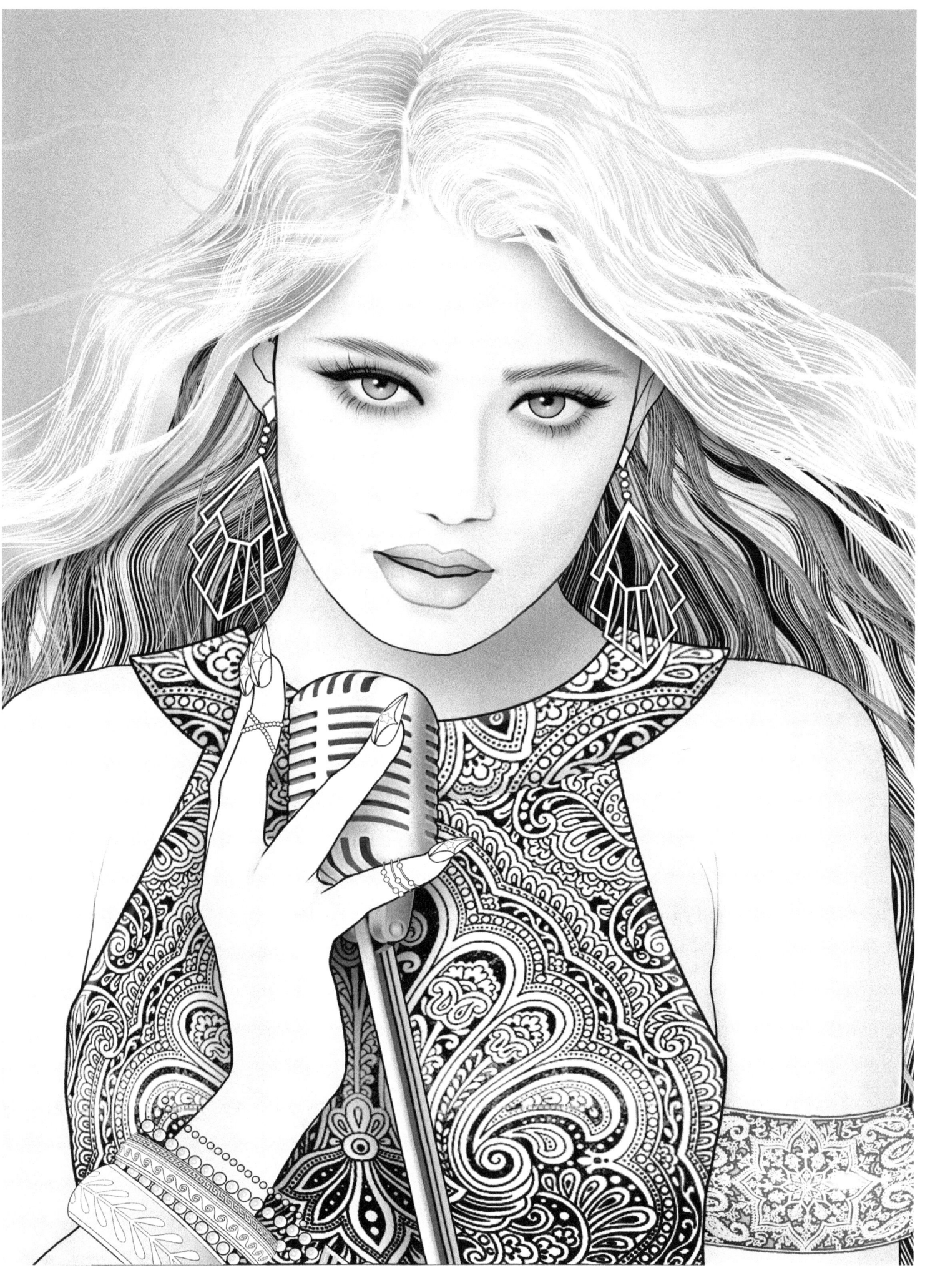

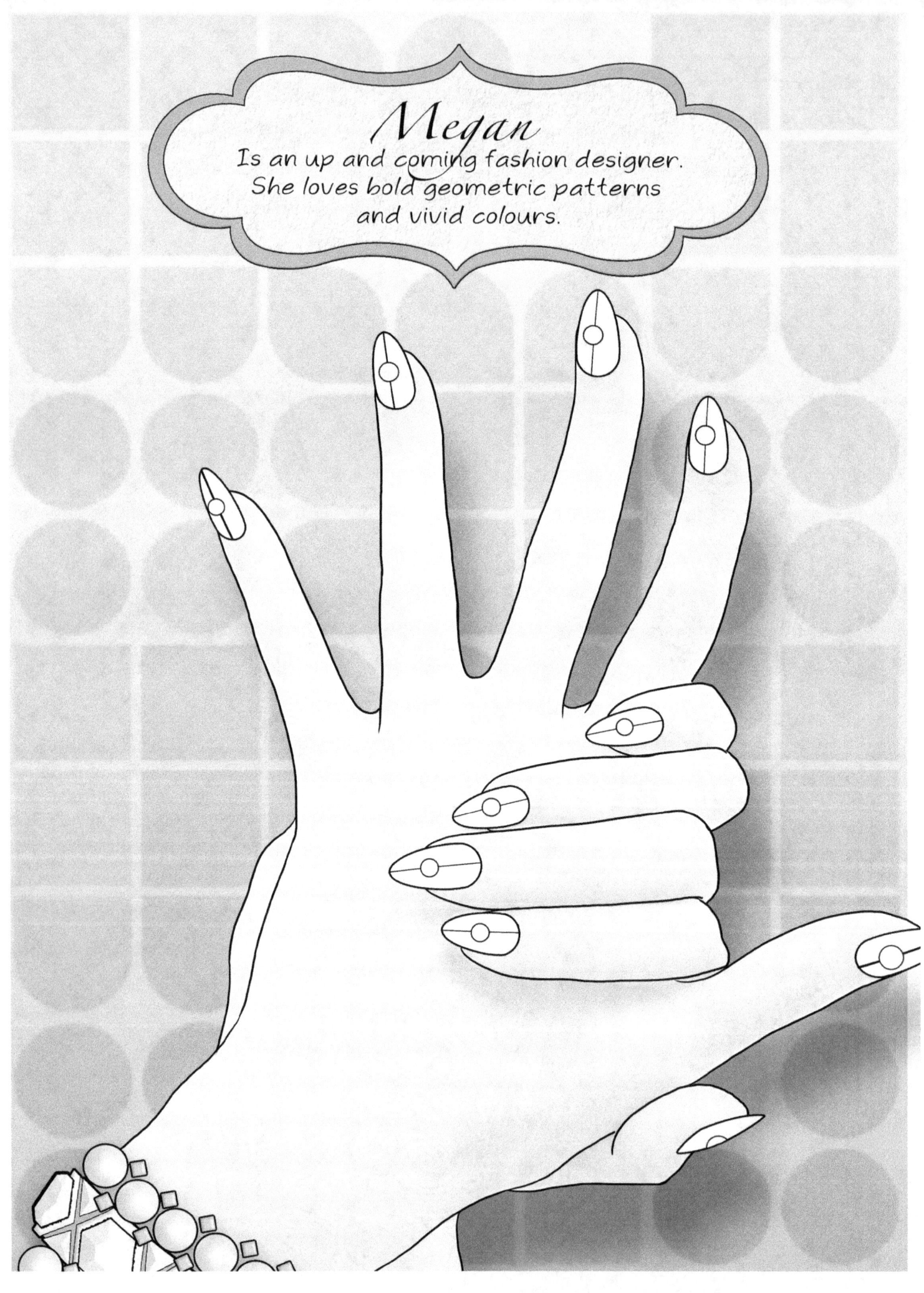

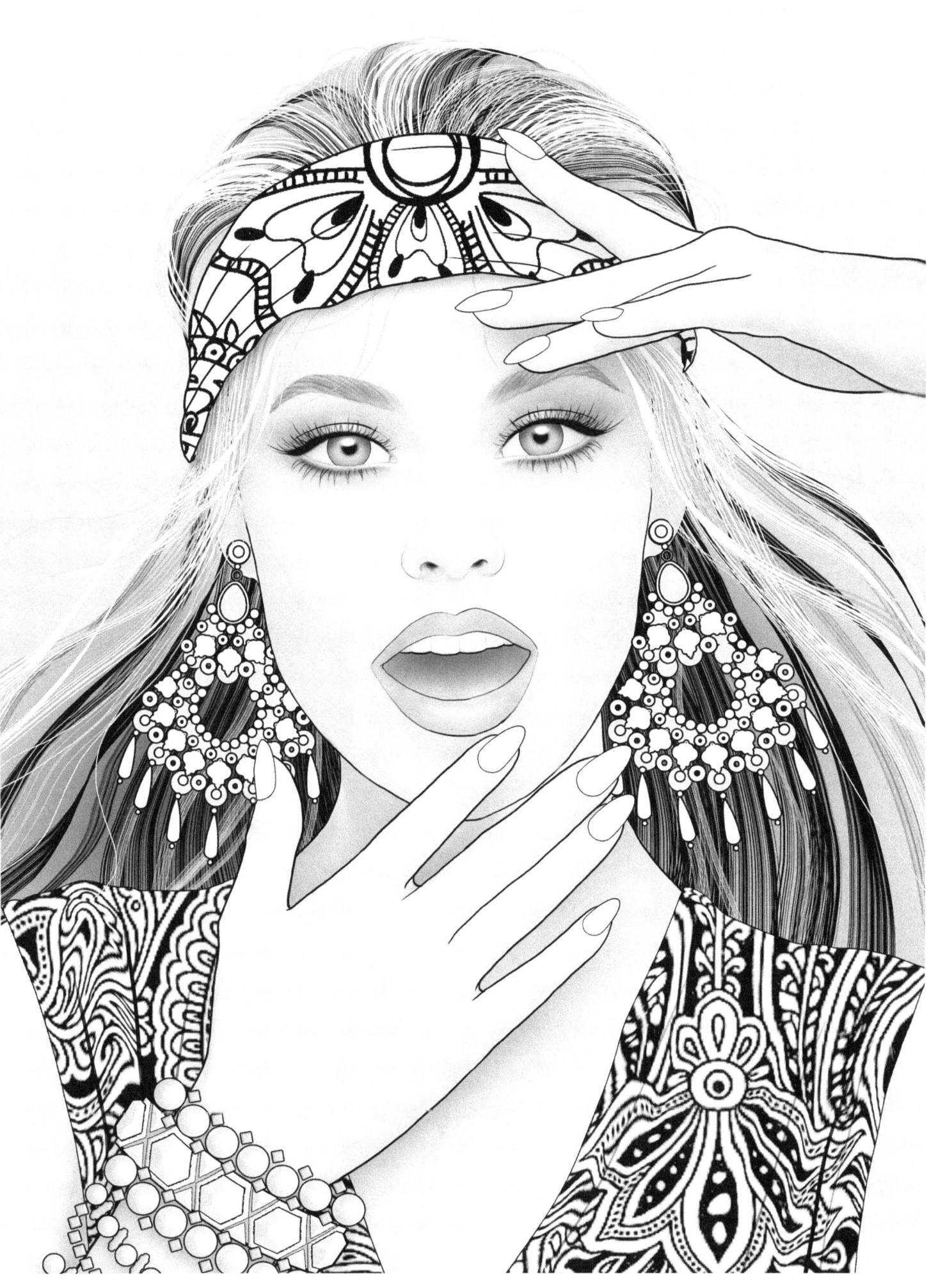

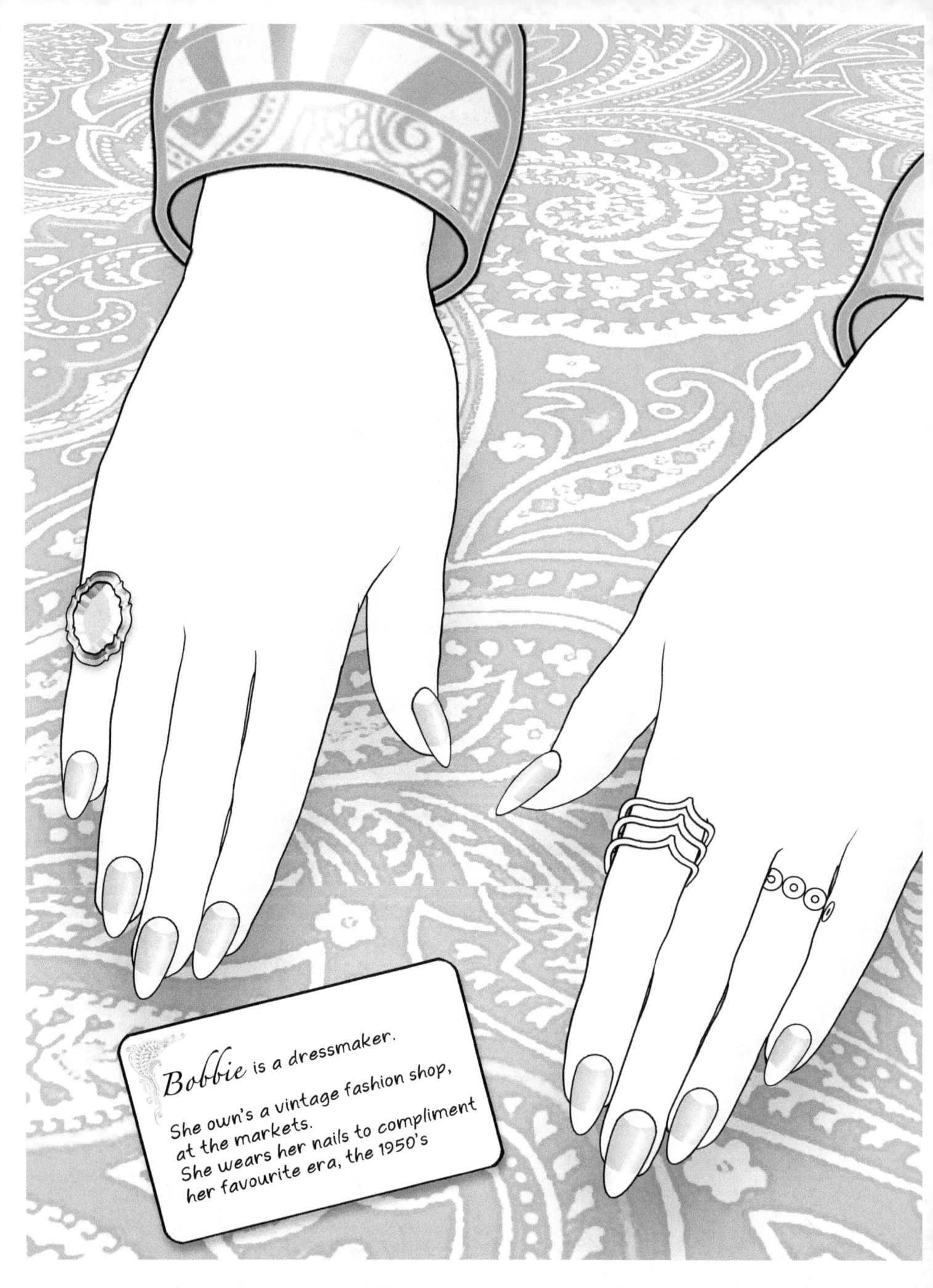

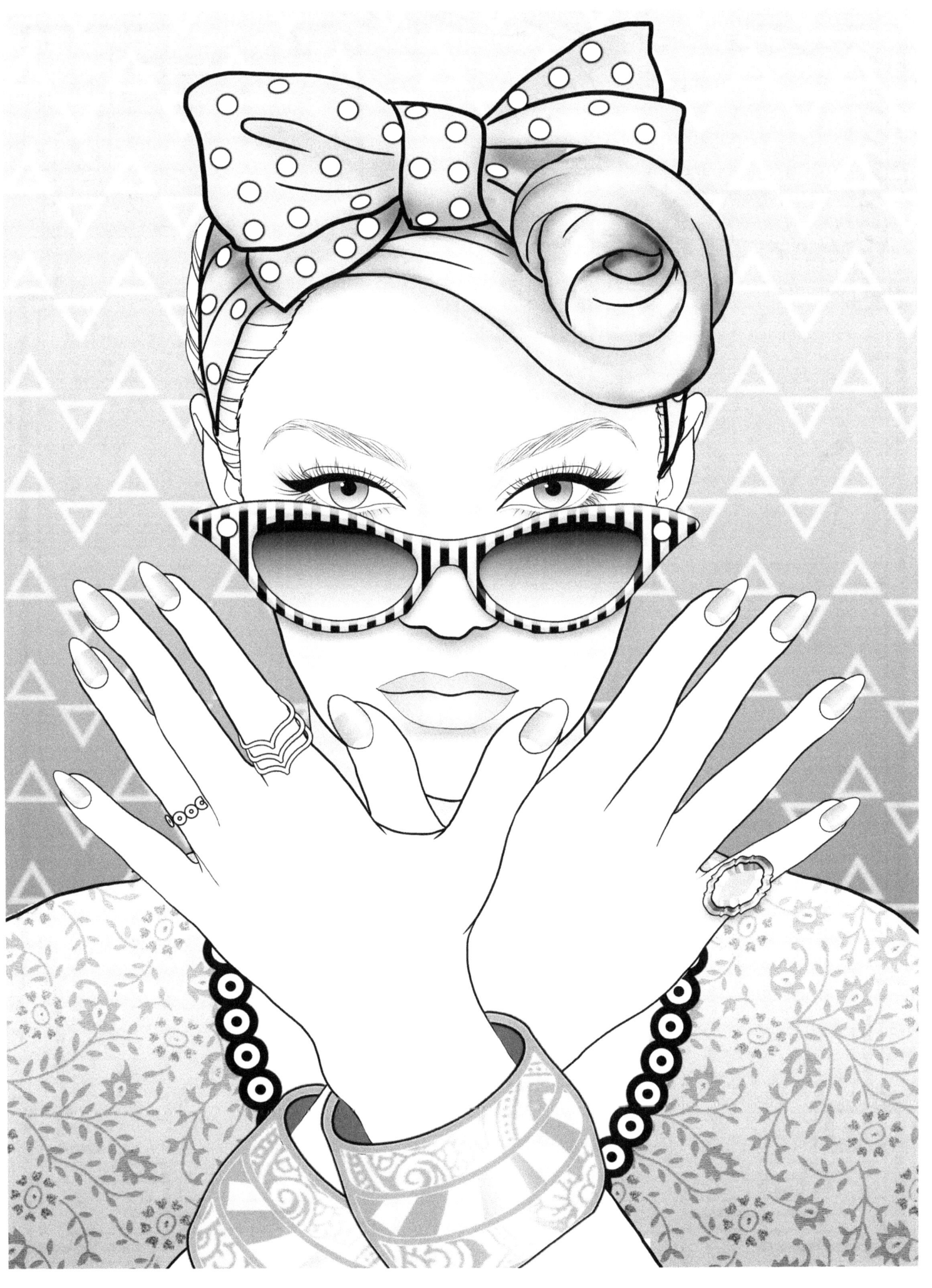

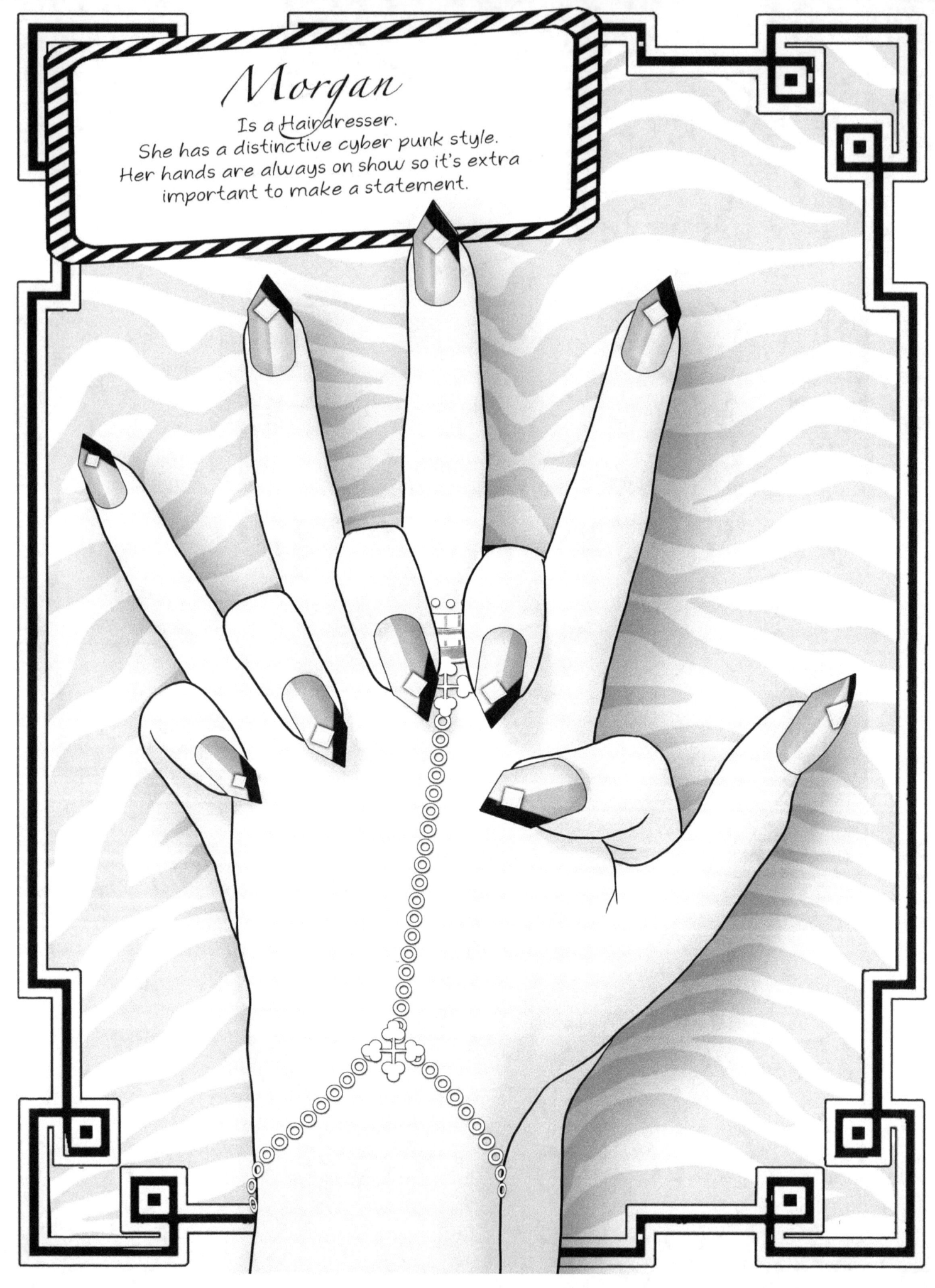

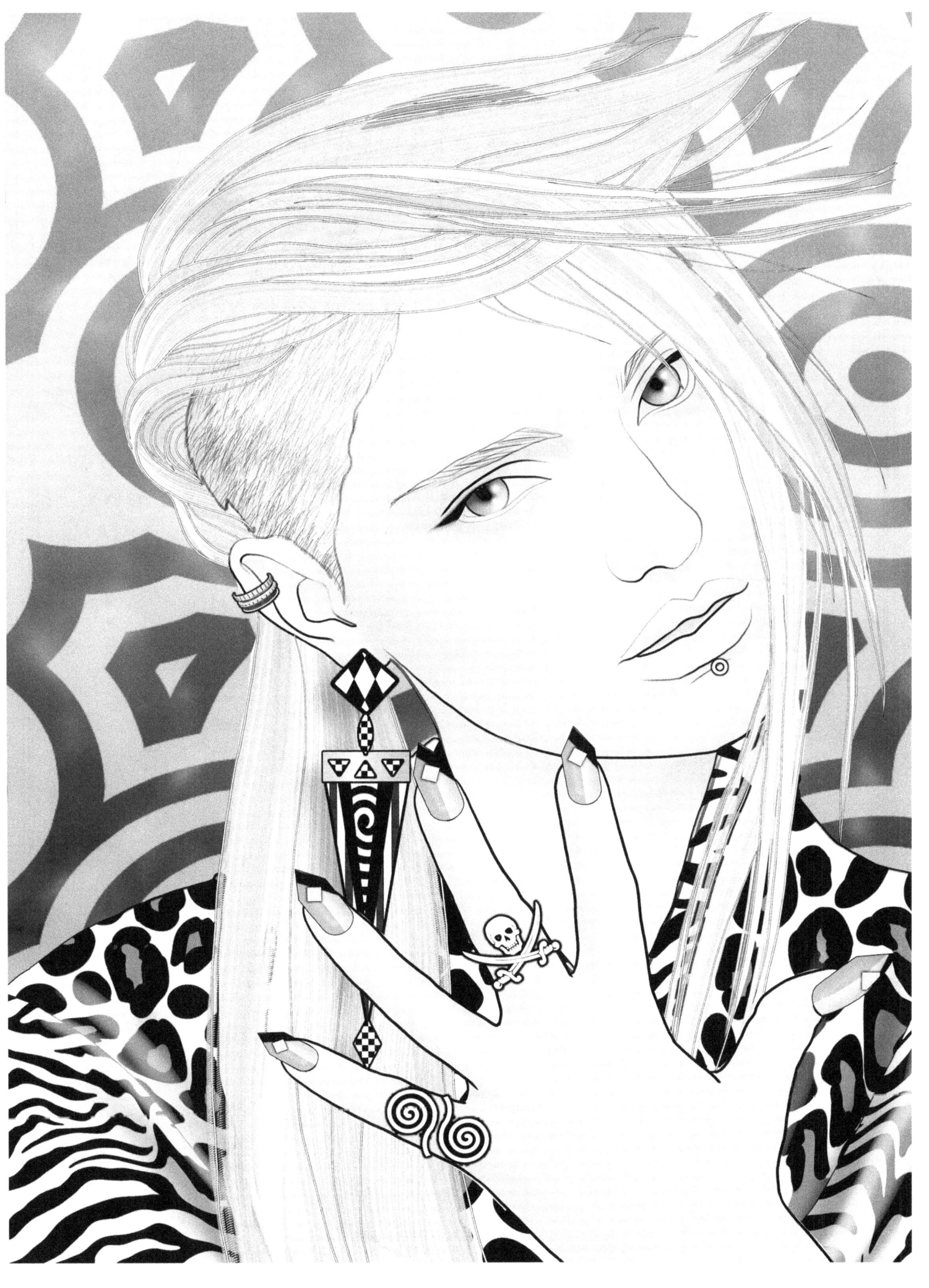

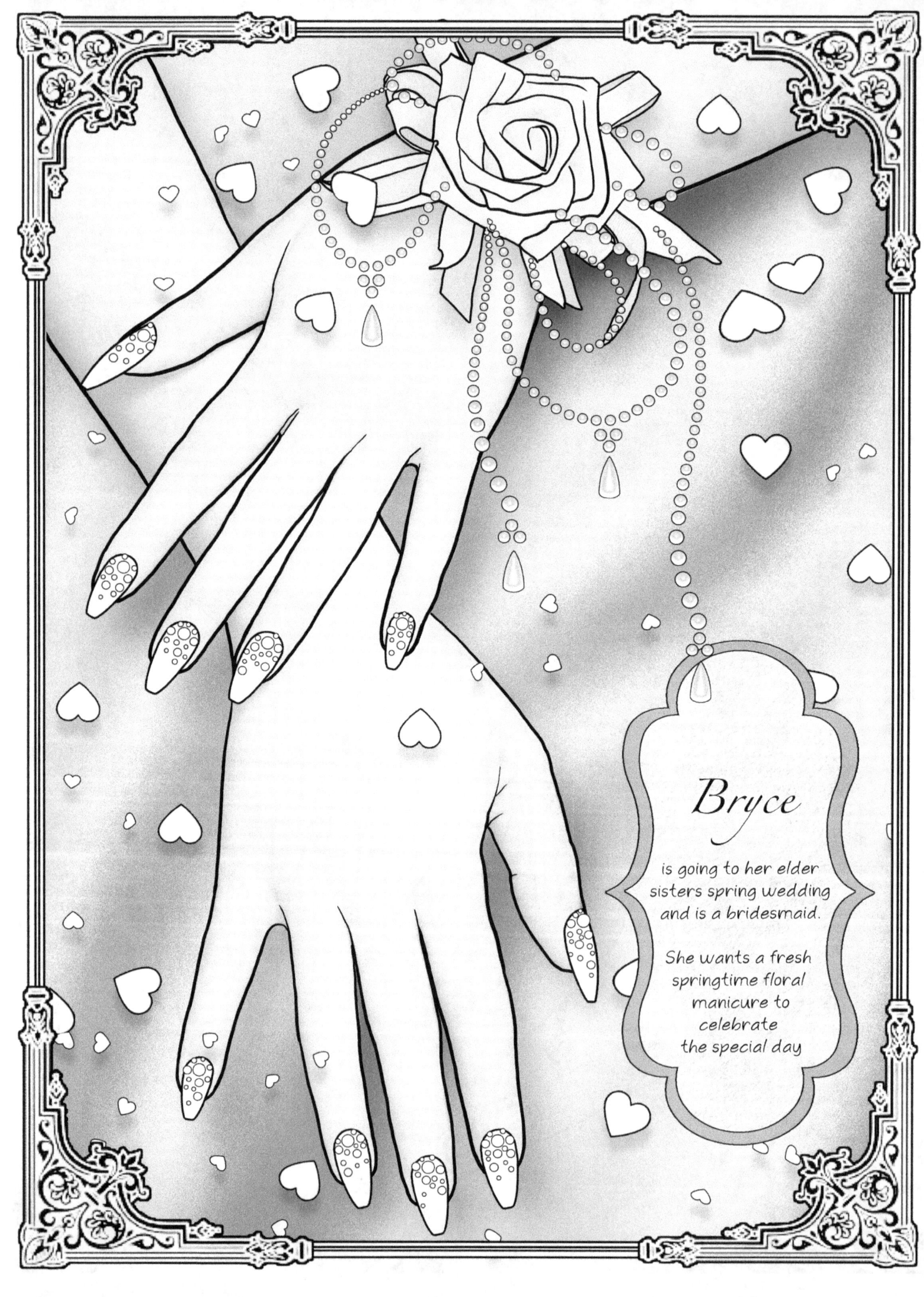

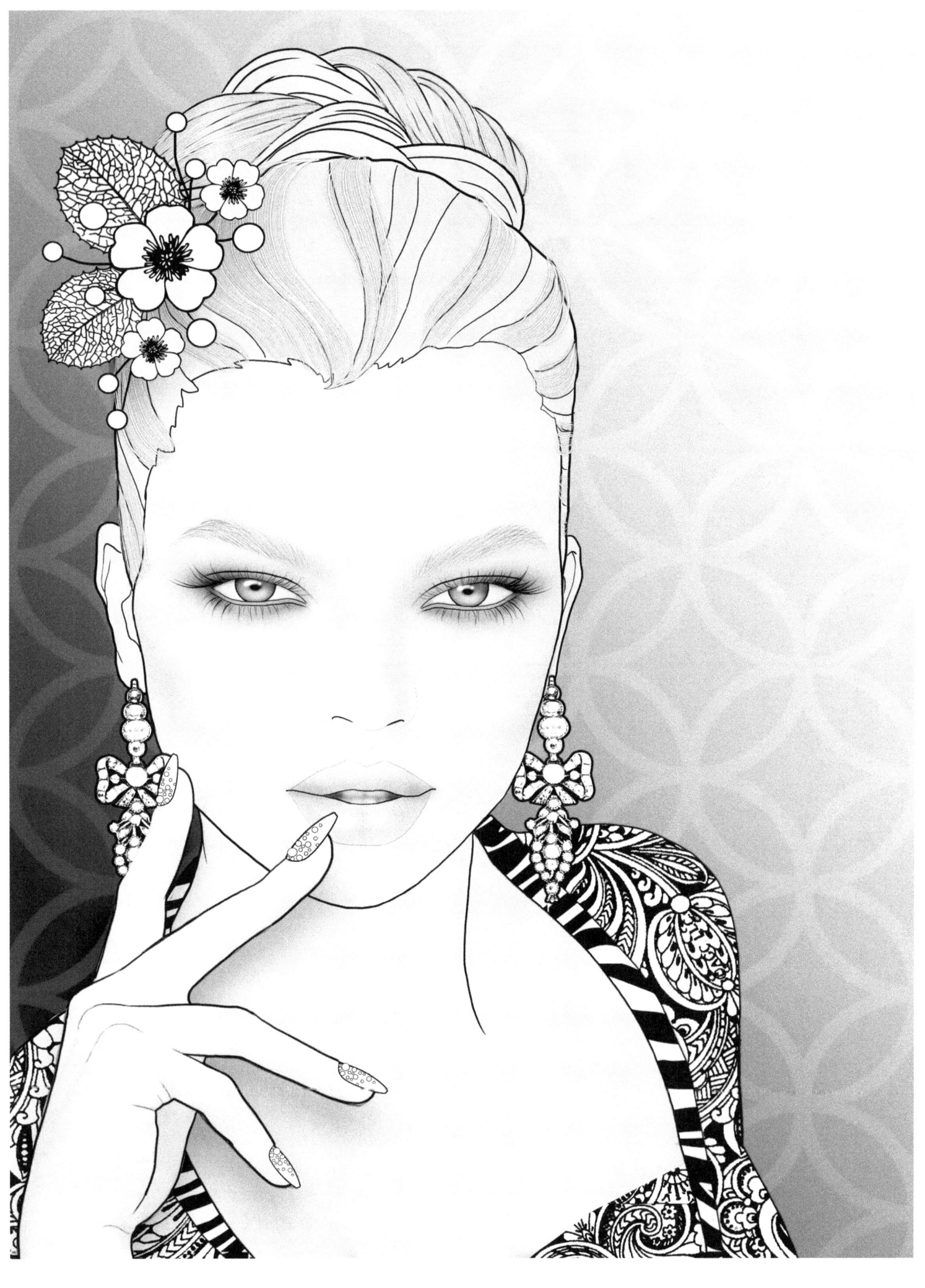

My Nail Art Collection

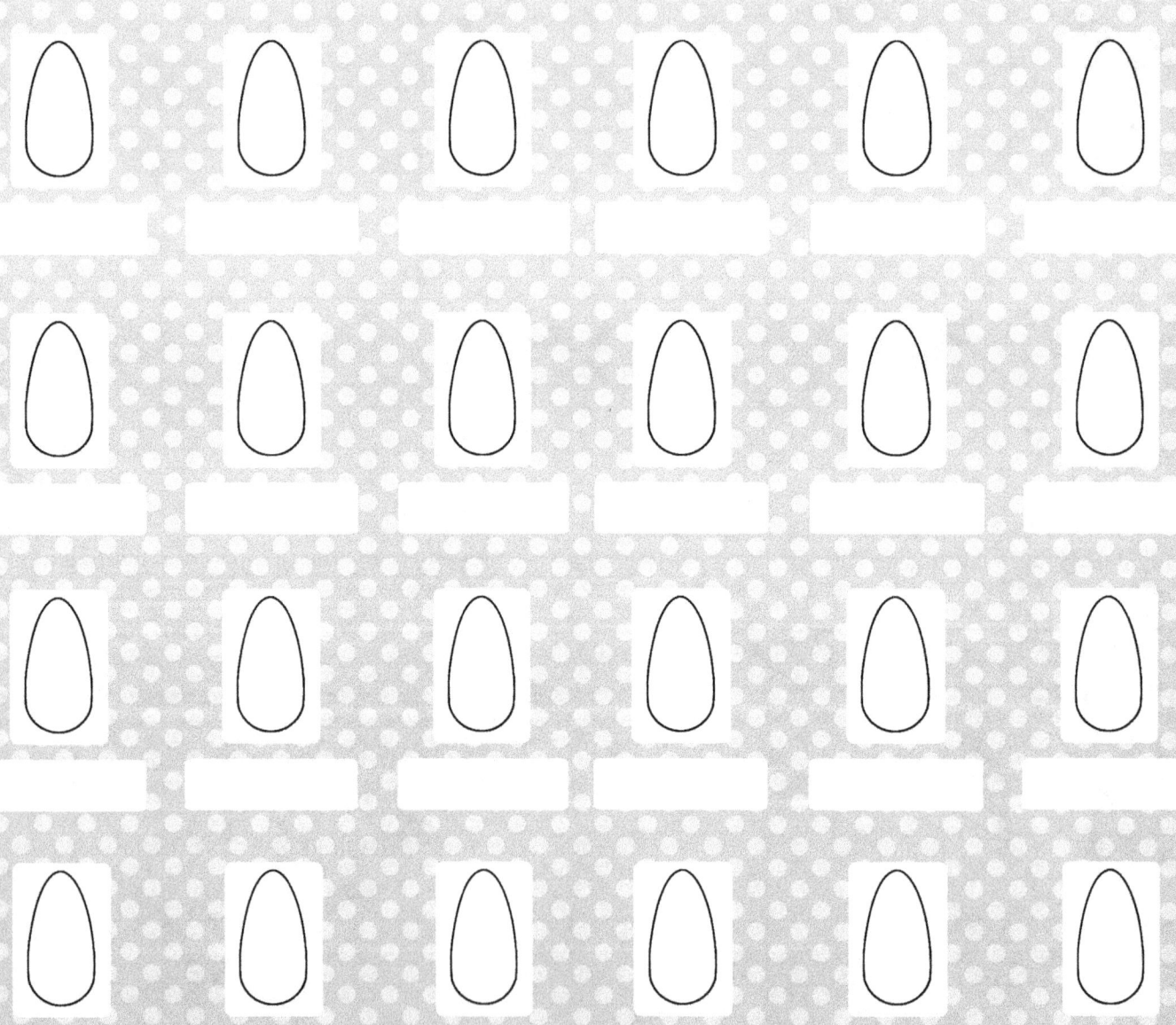

Blank Nail Shapes
Paint the blank nail shapes with your own nail polish
Or use creative colour with your coloured pens.
Remember to allow the nail polish to dry so the pages don't stick together

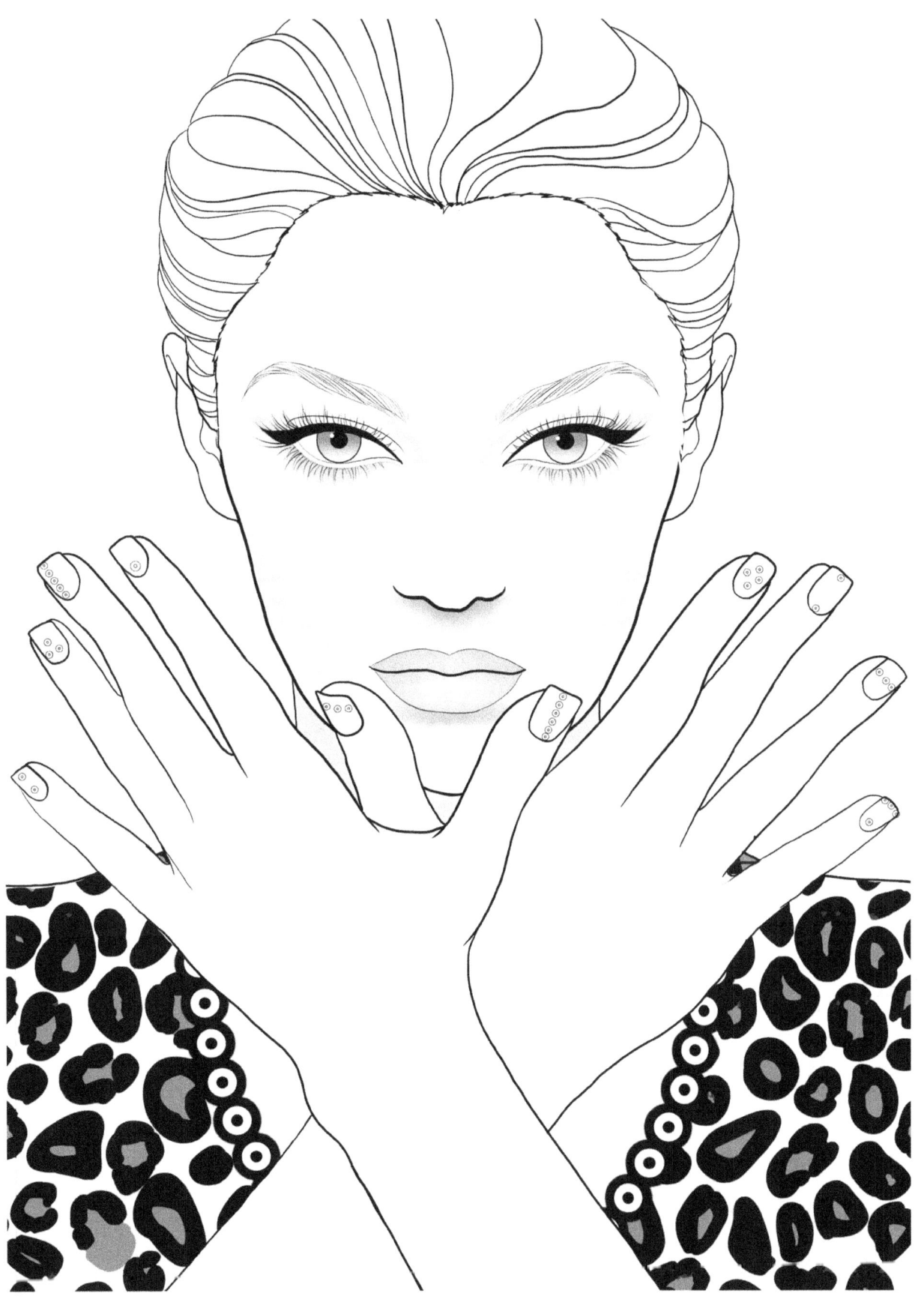

Practice Page

My NAIL SPA

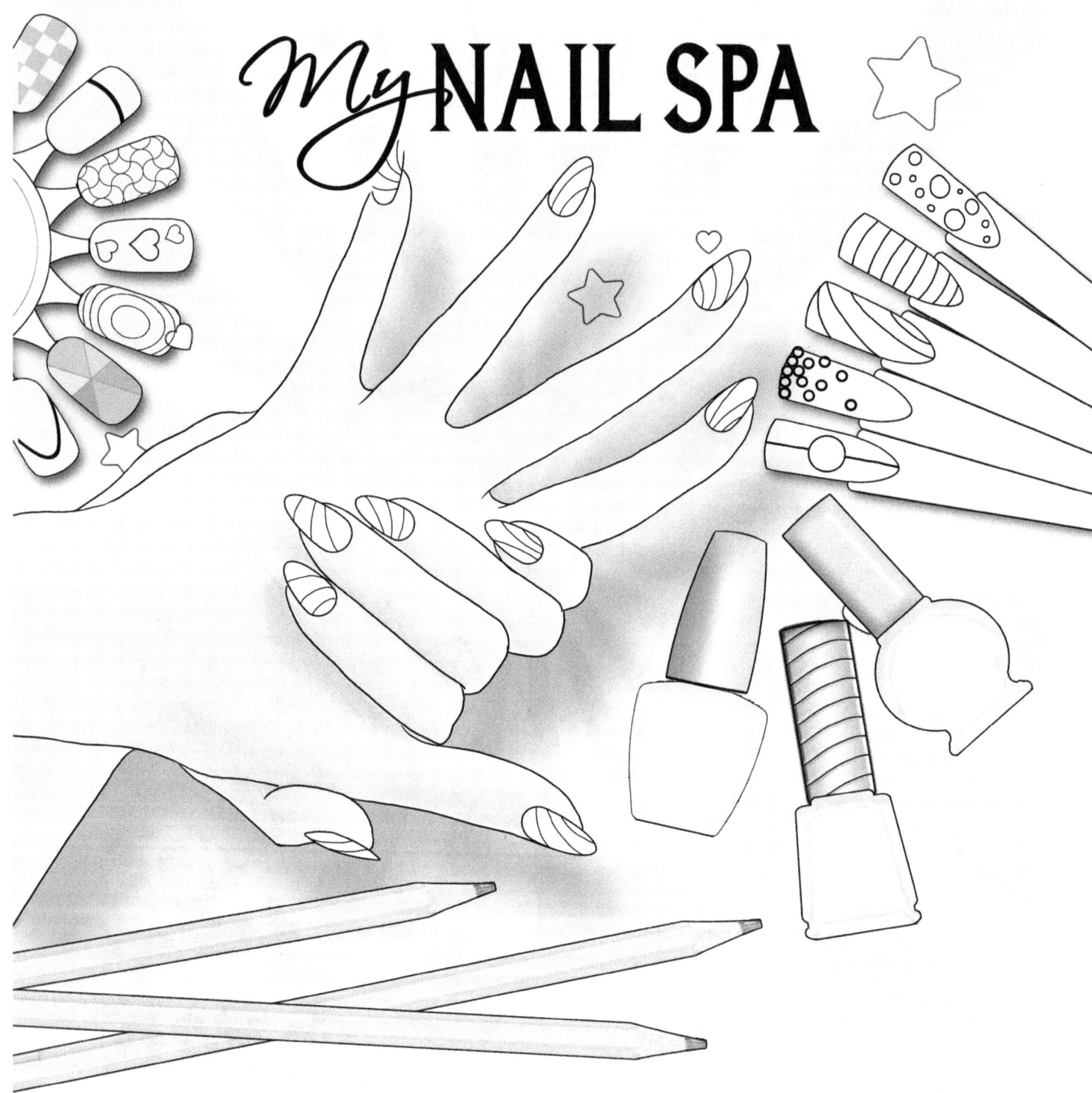

Create your own *Nail Art*.
I hope you enjoy this fun colour-in book which
contains great projects and fun clients to practice with.

You will learn some aspects of
the glamorous world of Nail Art.

copyright © Maxine Gadd 2016

www.ingramcontent.com/pod-product-compliance
Lightning Source LLC
Chambersburg PA
CBHW080523190526
45169CB00008B/3036